peaceful places
San Francisco

peaceful places
San Francisco

110 Tranquil Sites in
The City and the Greater Bay Area

by Raynell Boeck

MENASHA RIDGE PRESS
www.menasharidge.com

Copyright © 2011 by Raynell Boeck
All rights reserved
Published by Menasha Ridge Press
Printed in the United States of America
Distributed by Publishers Group West
First edition, first printing

Cover design by Scott McGrew
Text design by Annie Long
Cartography by Steve Jones
Unless otherwise noted, all photographs by Raynell Boeck
Cover photograph © Michelle Gibson/iStock: Palace of Fine Arts, page 141.

Library of Congress Cataloging-in-Publication Data

Boeck, Raynell.
 Peaceful places San Francisco : 110 tranquil sites in the city and the Greater Bay Area / by
 Raynell Boeck. —1st ed.
 p. cm.
 ISBN-13: 978-0-89732-718-3
 ISBN-10: 0-89732-718-7
 1. San Francisco (Calif.)—Guidebooks. 2. San Francisco Bay Area (Calif.)—Guidebooks. 3. Qui-
 etude. I. Title. II. Title: One hundred ten tranquil sites in the city and the Greater Bay Area.
 F869.S33 B
 979.4'61--dc22
 2010034527

Menasha Ridge Press
P.O. Box 43673
Birmingham, Alabama 35243
menasharidge.com

Disclaimer

Seclusion can be part of the charm of a peaceful place. Likewise, in some locations, the best time to visit is early morning, sunset, or even in the evening, when few other people are around. Therefore, we remind you to maintain awareness and practice caution in all of the destinations described in this book just as you would when venturing to any isolated or unfamiliar location. Please also note that prices, hours, and public-transportation routes can fluctuate over time, and that information often changes under the impact of many factors that influence the travel industry. We therefore suggest that you write or call ahead for confirmation when making your travel plans. Every effort has been made to ensure the accuracy of information throughout this book, and the contents of this publication are believed to be correct at the time of printing. Nevertheless, the publisher cannot accept responsibility for errors or omissions, for changes in details given in this guide, or for the consequences of relying on any information provided by the same. Assessments of sites are based on the author's own experience; therefore, descriptions given in this guide necessarily contain an element of subjective opinion, which may not reflect the publisher's opinion or dictate a reader's own experience on another occasion.

contents

peaceful places alphanumerically

dedication

For my family and friends, who bring me peace.

acknowledgments

*C*ountless people have enriched the writing of this book. My thanks go first to the creators and caretakers, both historic and contemporary, of the tranquil places presented in these pages. Through their vision, innovation, and stewardship, they have enhanced our enjoyment of the San Francisco Bay Area's natural wonders. They have inspired our dreams of the perfect peaceful escape.

For her wisdom, encouragement, and support, I would like to thank Danielle Crafton. A large debt of gratitude goes to Rebecca and George Fong for their unwavering belief in me. I tip my hat to Curt Olsen for joining me in some of my earliest explorations. Thank you to members of the Boeck family—Elida, Linda, and Rory—for our many discussions about the project and for keeping me going. I also want to thank my sister Roxanne Spizzirri for sharing her knowledge of California history and for her enthusiastic company on some of my excursions. Thank you to Faith Kapell, who provided invaluable advice during the project. A special thanks to Rick Boeck, who brought his critical eye to bear in helping me enhance my photograph selections, and to Rachel Fong, who looked at peaceful places through the lens of her camera.

Heartfelt thanks go to Elizabeth Adams for her creative suggestions and for taking me on a journey to peaceful East Bay venues. I am also indebted to William Craumer, not only for his friendship and insights but also for introducing me to places of unparalleled serenity in the Napa Valley and deep in the Santa Cruz Mountains. I also benefited from the gracious support of Julie Stein, who showed me the hushed reading rooms at the University of California, Berkeley, and calm sites on that sylvan campus.

Thanks also go to Doug Akagi for his patient responses to my inquiries and for sending me in the direction of numerous restorative places in Marin County. Julie Goldman,

who remained a steadfast friend throughout hours of navigation and exploration on the Peninsula, deserves my immense gratitude. Some of these friends have also been wonderful dining companions at quiet tables along the way.

My appreciation also goes to Janet Von Doepp for approaching the helpful team at the California Academy of Sciences on my behalf and for expanding my knowledge of this San Francisco treasure. Without Amy Garant's artistic insights, I may have overlooked what became two of my favorite destinations. Thank you, Judith Gordon, Larry Banka, Peter Magnani, and John Keane, for steering me to several important San Francisco venues. Another debt of gratitude goes out to gallery owners Charles Hespe and Donna Seager for their gracious welcome and illuminating insights.

I would be remiss if I didn't express my gratitude to the many individuals and unsung heroes whose names I don't even know but who contributed immeasurably. Thank you to the librarians, docents, park rangers, spokespersons, history buffs, winery aficionados, store owners, spa attendants, restaurant servers, and members of the Bay Area community who engaged in lively conversation about this project and provided valuable resources.

Finally, I have been incredibly fortunate to have as my editor and friend Susan Haynes, who suggested that I write this book and who encouraged me every step of the way. Her keen sense of the American public's need to slow down and recharge provided the impetus for the project. Her discernment, gifted editorial sensibility, and impeccable judgment helped enliven the prose. Without Susan, this book would not have become a reality.

Raynell Boeck
San Francisco
September 2010

*A*s I started writing this book, I found myself thinking about the many ways in which we talk about our pursuit of serenity and relaxation. We seek to refresh, de-stress, slow down, chill out, mellow out, achieve balance, be who we really are, find inner peace, put things into perspective, and get our priorities straight. We want to find our bliss, make room for play, grab some alone time, stay in the moment, walk around the block, get away from it all, take a deep breath, and not wait to exhale.

But the truth of the matter is, in many cases, all we do is talk. Say what we will, we often don't know how to find our bliss. We're at a bit of a loss when it comes to achieving outer, let alone inner, peace. In San Francisco and the Bay Area—where the parade of people is a given, the temptations to excess are great, and noise is a constant—solitude, when we crave it, seems even more elusive. At a time when economic downturn has changed our lives and we just might be headed for our own emotional meltdown, solitude seems ever more necessary.

With this conundrum in mind, I began to formulate the question: Where and when in our city and the greater Bay Area can we find some precious quiet and much-needed balm for the soul? Out of that inquiry, and my resulting pilgrimage to more than 110 tranquil spots in the metropolitan area and beyond (including the ones that didn't make the final list), this book was born.

Recognizing that one person's temple of relaxation is another person's all-too-sedentary pastime, I've attempted to present you with some options, each intended to work its restorative magic. You will find little garden paradises, big wooded parks, remote hiking trails, resplendent chapels, stairway walks, urban waterfalls, ocean views, and surf within earshot. If you want a dose of culture, consider this book your guide to hushed libraries

and reading rooms, lesser-known museum alcoves, cafes where lingering over your glass of wine is encouraged, and galleries where quiet contemplation of the art is a deliberate part of the aesthetic. Some sites will seem like your own secret discovery. With others, you may just be renewing a fond acquaintance. In some cases, you may have to suspend your preconceived notions about a venue's capacity to serve up a soothing experience. Try the place during the off-peak hours, days, or seasons that I suggest in the entries.

This book is also as much about leading you to oases of tranquility as it is about giving you a sense of each place and, perhaps, your connection to it. After living in San Francisco for more than 30 years, I emerged from my own explorations with a deeper appreciation of and respect for the Bay Area's treasures, both natural and of human imagining.

In creating this book, I came across the apt words of 19th-century essayist Ralph Waldo Emerson, who cautioned: "Guard well your spare moments. . . . Improve them and they will become the brightest gems in a useful life." Here are 110 peaceful places where you can give your spare moments the tender loving care they deserve.

Raynell Boeck
San Francisco
September 2010

P.S.: This book tells you how to reach destinations by bus, ferry, metro, or rail (including the transbay BART system). It generally provides information for public transportation that arrives closest to the destinations. If such information is unavailable, or where multiple transfers get so complicated that they undermine the tranquil experience, you will see "N/A" (not applicable).

three paths to 110 peaceful places

*I*n *Peaceful Places: San Francisco*, author Raynell Boeck serves up 110 locales for a few hours of quiet time in the greater metro area and farther afield. To make it easy for you to find an entry that suits your mood and desired neighborhood or type of place, we've organized the sites in three different ways:

the path BY CATEGORY

The Peaceful Places by Category guide (page xviii) organizes the sites into 12 different groups, as listed below. The full text for each destination also includes its category at the top of that individual entry. In many cases it was difficult to classify a place, as it might be a historic site in an outdoor habitat with a scenic vista that feels like a spiritual enclave that is an urban surprise where you can take an enchanting walk! But we tagged each of the sites as seemed most fitting for the focus of the author's description.

Day Trips & Overnights	Outdoor Habitats	Scenic Vistas
Enchanting Walks	Parks & Gardens	Shops & Services
Historic Sites	Quiet Tables	Spiritual Enclaves
Museums & Galleries	Reading Rooms	Urban Surprises

the path BY AREA

The Peaceful Places by Area guide (page xxii) and maps (page xxvii) locate sites according to these ten geographic divisions:

Downtown San Francisco (MAP ONE)

Chinatown, The Embarcadero, Financial District, Jackson Square, Nob Hill, North Beach, Russian Hill, Telegraph Hill, and Union Square

South of Market & Southeastern Neighborhoods (MAP TWO)
Bernal Heights, China Basin, Dogpatch, Potrero Hill, South of Market, and South Park

Civic Center & Western Addition (MAP THREE)
Alamo Square, Civic Center, Hayes Valley, Japantown, and Western Addition

Mission District & Environs (MAP FOUR)
The Castro, The Mission, and Noe Valley

Marina District, The Presidio, & Pacific Heights (MAP FIVE)
The Marina, Pacific Heights, and The Presidio

The Richmond, The Sunset, & Southwestern Neighborhoods (MAP SIX)
Golden Gate Park, The Richmond, The Sunset, and Twin Peaks (West)

East Bay (MAP SEVEN)
Berkeley, Oakland, and Richmond

Marin County* (MAP EIGHT)
Belvedere/Tiburon, Corte Madera, Marin Headlands, Mill Valley, Muir Beach, San Anselmo, San Rafael, and Sausalito

The Peninsula (MAP NINE)
Burlingame, Menlo Park, Palo Alto–Stanford University, Portola Valley, San Mateo, and Woodside

Farther Afield (MAP TEN)
Clayton, Cupertino, Danville, Felton, Freestone, Martinez, Napa Valley, and Point Reyes National Seashore (western Marin County)

*See Map Ten for Point Reyes National Seashore, in western Marin County.

the path **ALPHANUMERICALLY**

Beginning on page 1, each entry unfolds in the main text in alphabetical order and is numbered in sequence. The number travels with that entry throughout the book in the table of contents (page v), in the Peaceful Places by Category guide (page xviii), in the Peaceful Places by Area guide (page xxii), and on the maps (page xxvii).

PEACEFULNESS RATINGS

Preceding the main text for each profile, listed information notes the entry's category and area. This capsule information also includes the author's rating for the site, on a scale of one to three stars, as follows:

✪✪✪ Heavenly anytime

✪✪ Almost always sublime

✪ Tranquil if visited as described in the entry—during times of day, week, season, and so on—and possibly avoided at certain times

ESSENTIALS

At the end of each entry you will find the destination's full address, telephone number, Web site, cost of entry or price ranges for menu items or other expenses, hours, and public-transportation choices. Hours and prices are subject to change, so call to verify before visiting a site.

Regarding public transportation: as the author points out in her introduction, on page xiii, "N/A" (not applicable) denotes destinations not reachable—or not easily accessible—via these services. And as San Franciscans and other urban dwellers know, public-transportation schedules and routes are subject to change. The routes and connections provided were up-to-date at press time, but please check the appropriate Web sites to be sure you have the latest information for your own journeys.

Throughout the San Francisco Bay Area, your leading choices for public transportation are as follows, in alphabetical order, according to the carrier's name:

Alameda–Contra Costa Transit District (AC Transit) serves western Alameda and

Contra Costa counties in the East Bay. It also operates service across San Francisco Bay to San Francisco and to selected areas in San Mateo and Santa Clara counties on the Peninsula. Visit **actransit.org.**

Bay Area Rapid Transit (BART) is a heavy-rail public-transit system that connects San Francisco with communities in the East Bay and in northern San Mateo County. Visit **bart.gov.**

Blue & Gold Fleet, Red & White Fleet, Golden Gate Ferry, Alameda/Oakland Ferry, and **Baylink Ferry** operate major ferry service between San Francisco and other parts of the Bay Area. Visit **blueandgoldfleet.com, redandwhite.com, goldengate.org, eastbayferry.com,** or **baylinkferry.com.**

Golden Gate Transit provides bus service in Marin and Sonoma counties in the North Bay, with limited service to San Francisco and to Contra Costa County in the East Bay. Visit **goldengate.org.**

The free **PresidiGo Shuttle** features two routes: a continuous loop within the Presidio, making stops at nearly 40 park destinations and serving the general public; and a downtown shuttle that serves Presidio residents and members of the general public during specified times. Visit **presidio.gov,** and click on "Transportation Information."

In general, **San Francisco Municipal Transportation Agency (SFMTA)** provides bus, streetcar, and metro (light-rail) service in the city of San Francisco, with limited service to the Marin Headlands. Visit **sfmta.com.**

The Peninsula-based **San Mateo County Transit District (SamTrans)** provides bus service throughout San Mateo County and into portions of San Francisco and Palo Alto. The commuter rail line Caltrain serves the San Francisco–San Jose corridor and is administered, in part, by SamTrans. Visit **samtrans.com.**

For more instructions on the diverse public-transportation systems and trip planning in San Francisco and the greater Bay Area, visit **transit.511.org.**

—*The Publisher*

peaceful places by category

DAY TRIPS & OVERNIGHTS

ENCHANTING WALKS

HISTORIC SITES

MUSEUMS & GALLERIES

SHOPS & SERVICES

SPIRITUAL ENCLAVES

URBAN SURPRISES

peaceful places by area

DOWNTOWN SAN FRANCISCO (Map One)

SOUTH OF MARKET & SOUTHEASTERN NEIGHBORHOODS (Map Two)

THE RICHMOND, THE SUNSET, &
SOUTHWESTERN NEIGHBORHOODS (Map Six) *(continued)*

EAST BAY (Map Seven)

MARIN COUNTY* (Map Eight)

**Entries at Point Reyes National Seashore, in western Marin County, appear on Map Ten.*

THE PENINSULA (Map Nine)

FARTHER AFIELD (Map Ten)

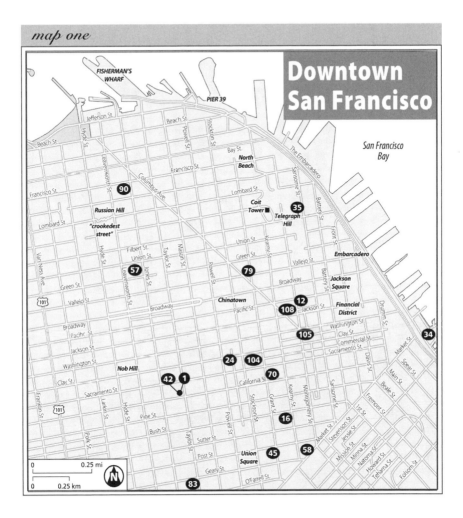

map one

Downtown San Francisco

FISHERMAN'S WHARF

PIER 39

San Francisco Bay

Jefferson St.
Beach St.
Beach St.
Hyde St.
Bay St.
North Beach
Francisco St.
Stockton St.
Powell St.
Leavenworth St.
Columbus Ave.
Francisco St.
Lombard St.
The Embarcadero
Sansome St.

90

Russian Hill

"crookedest street"

Coit Tower
Telegraph Hill

35

Lombard St.
Battery St.
Front St.

Union St.

Van Ness Ave.
Hyde St.
Filbert St.
Union St.
Taylor St.
Mason St.
Green St.
Kearny St.
Embarcadero

Green St.
Leavenworth St.
Jones St.
Powell St.
Vallejo St.
Broadway
Jackson Square
Battery St.

57

79

101

Vallejo St.
Broadway

Chinatown
Pacific St.

12

108 Jackson St.

Financial District

Drumm St.

Broadway
Pacific St.
Jackson St.
Washington St.

105

Washington St.
Clay St.
Commercial St.
Sacramento St.
Davis St.

34

Clay St.
Nob Hill

42 1

24 104

70

California St.

Sacramento St.
Larkin St.
Hyde St.

Franklin St.
101
Pine St.
Bush St.
Taylor St.
Powell St.
Stockton St.
Grant St.
Kearny St.
Montgomery St.
Sansome St.
Battery St.
Main St.
Beale St.
Spear St.
Fremont St.

16

Sutter St.
Post St.
Geary St.
O'Farrell St.

Union Square

45 58

Polk St.

Market St.
Stevenson St.
Jessie St.
Mission St.
Minna St.
Natoma St.
Howard St.
Tehama St.
Folsom St.

0 0.25 mi
0 0.25 km

83

N

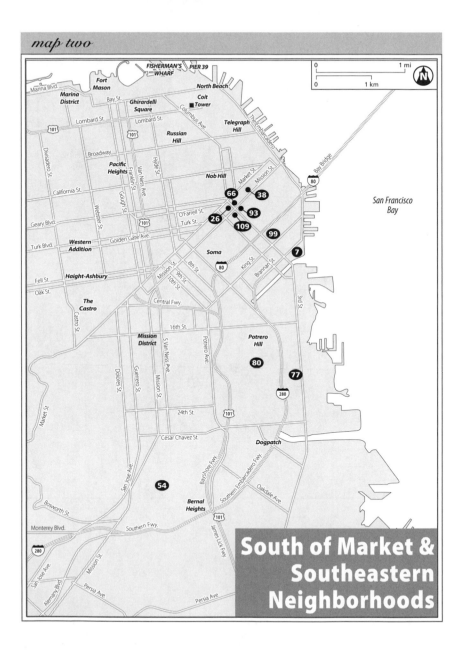

map two

South of Market &
Southeastern
Neighborhoods

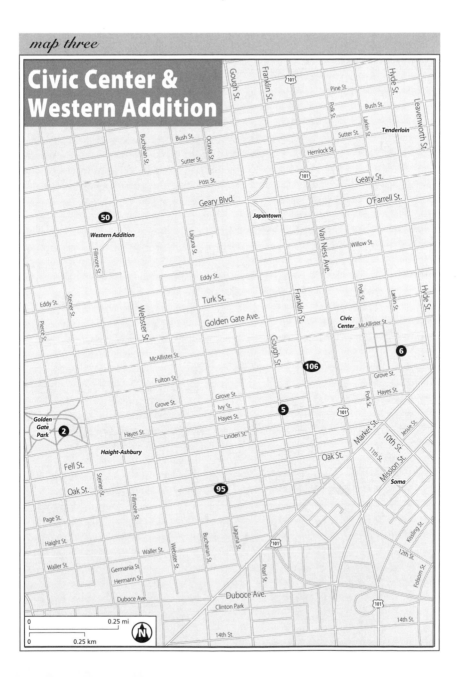

map three

Civic Center & Western Addition

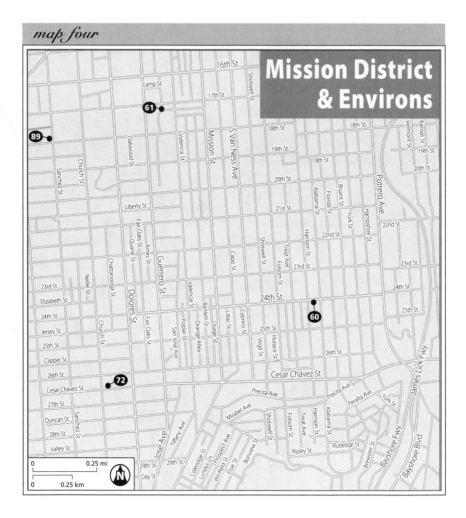

map four

Mission District & Environs

0 0.25 mi
0 0.25 km

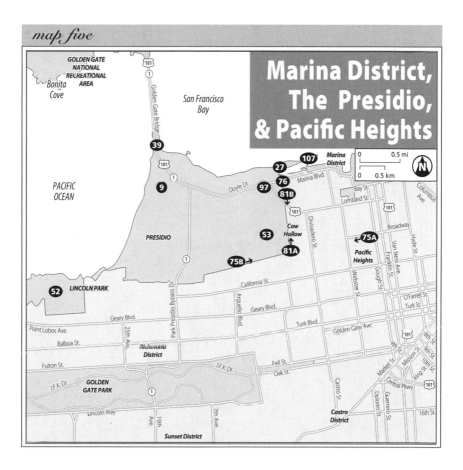

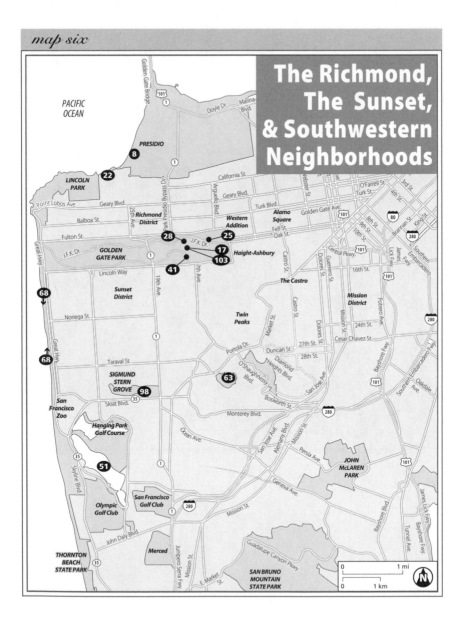

map six

The Richmond, The Sunset, & Southwestern Neighborhoods

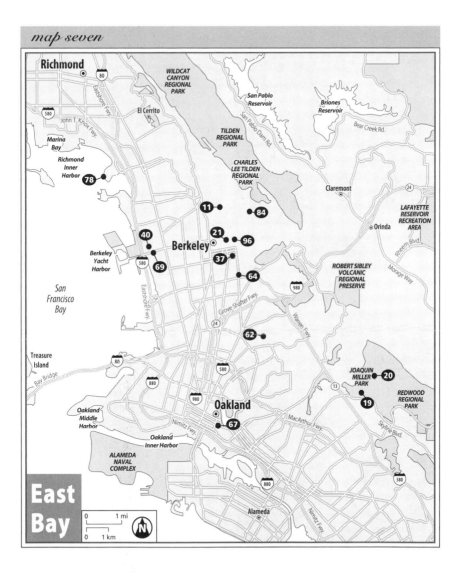

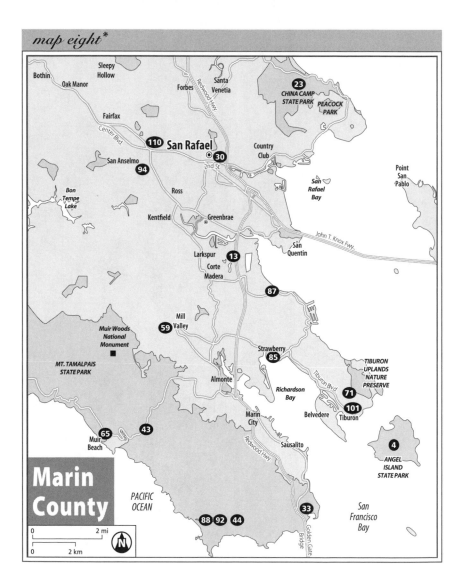

map eight

Sleepy
Hollow

Bothin
Oak Manor

Santa
Forbes Venetia

23
CHINA CAMP
STATE PARK PEACOCK
PARK

Fairfax

Center Blvd.

110 **San Rafael**

Country
Club

Point
San
Pablo

San Anselmo **94** **30**
2nd St.

Bon
Tempe
Lake

Ross

San
Rafael
Bay

Kentfield Greenbrae

John T. Knox Fwy.

Larkspur **13**
Corte
Madera

San
Quentin

87

Mill
Muir Woods **59** Valley
National
Monument

MT. TAMALPAIS
STATE PARK

Strawberry
85

TIBURON
UPLANDS
NATURE
PRESERVE

Almonte

Tiburon Blvd.

Richardson
Bay

71

Marin
City

Belvedere **101**
Tiburon

65 **43**

Muir
Beach

Redwood Hwy.

Sausalito

4

ANGEL
ISLAND
STATE PARK

Marin
County

PACIFIC
OCEAN

88 **92** **44**

33

San
Francisco
Bay

Golden Gate Bridge

0 2 mi
0 2 km N

*See Map Ten for Point Reyes National Seashore entries in western Marin County.

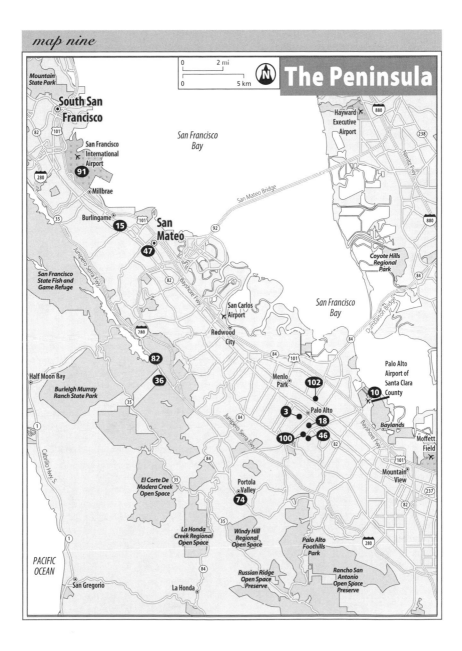

map nine

The Peninsula

0 2 mi

0 5 km

Mountain
State Park

South San
Francisco

San Francisco
Bay

Hayward
Executive
Airport

San Francisco
International
Airport

91

Millbrae

San Mateo Bridge

Burlingame

15

San
Mateo

47

San Francisco
State Fish and
Game Refuge

Coyote Hills
Regional
Park

San Carlos
Airport

San Francisco
Bay

Redwood
City

82

Half Moon Bay

Burleigh Murray
Ranch State Park

36

Menlo
Park

102

Palo Alto
Airport of
Santa Clara
County

10

3

Palo Alto

18

Baylands

Moffett
Field

100

46

Mountain
View

El Corte De
Madera Creek
Open Space

Portola
Valley

74

La Honda
Creek Regional
Open Space

Windy Hill
Regional
Open Space

Palo Alto
Foothills
Park

PACIFIC
OCEAN

San Gregorio

La Honda

Russian Ridge
Open Space
Preserve

Rancho San
Antonio
Open Space
Preserve

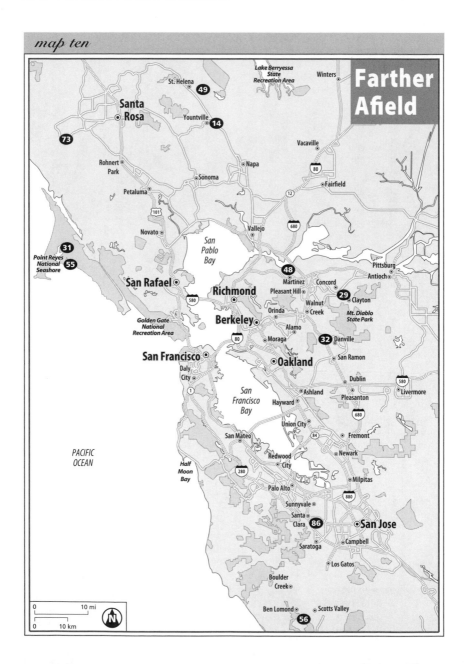

peaceful places
San Francisco

Listen to the sounds produced by the Wave Organ (Peaceful Place 107, page 200).

peaceful place 1

AIDS INTERFAITH CHAPEL AT GRACE CATHEDRAL

Nob Hill (MAP ONE)

CATEGORY ⌣ spiritual enclaves ✪ ✪ ✪

" *R*eally heavy" is how pop artist Keith Haring described the theme of his bronze and white-gold triptych altarpiece, completed just weeks before his death from AIDS. Today, his work *The Life of Christ* beautifies Grace Cathedral's AIDS Interfaith Chapel, my favorite place within the cathedral.

Occupying the main floor lobby of the Singing Tower, the chapel memorializes the many San Franciscans and individuals worldwide who have died of the pandemic, as well as people living with HIV/AIDS, their caregivers, and volunteers fighting for the cause. The subdued lighting, handcrafted furnishings, urns of white orchids, and hand-lettered *Book of Remembrance* create a melancholy yet serene sanctuary. A semicircle of chairs faces the radiant altarpiece and encourages you to contemplate the message of compassion that Haring has conveyed through his kinetic figures and bold lines. A colorful section of the AIDS Quilt—containing eight memorial names and fashioned from patchwork, appliqué, embroidery, and needlepoint—hangs in the rear of the chapel, inviting you to think for a moment about the lives led and lost.

On the chapel floor, an eight-point star of Virginia greenstone symbolizes renewal. If you happen to visit when the hour strikes, you'll hear the cathedral's mighty carillons ring out in the Singing Tower above you and feel the reverberations.

↶ essentials

⊡ 1100 California Street, San Francisco, CA 94108

𝒞 (415) 749-6300

🌐 gracecathedral.org

$ Free

🕐 Sunday, 8 a.m.–7 p.m.; Monday–Friday, 7 a.m.–6 p.m.; Saturday, 8 a.m.–6 p.m.

🚍 **Muni bus:** 1; **Muni Metro:** Powell Street Station; **Cable car:** California Street, Powell/
 Hyde Street, and Powell/Mason Street; **BART:** Powell Street Station

peaceful place 2

ALAMO SQUARE PARK

Western Addition (MAP THREE)

CATEGORY ⚲ parks & gardens ✪ ✪

*S*an Francisco's Neighborhood Parks Council surely had Alamo Square in mind when it asked residents to write online love letters to their favorite city park. One of the city's most photographed greenswards, the square is perhaps best known for the elite "painted lady" Queen Anne Victorian homes that face its eastern edge on Steiner Street, a block fancifully named Postcard Row.

But Alamo Square Park has a lot more going for it than its backdrop of pricey real estate. Situated in one of San Francisco's 11 historic districts and dating back to the

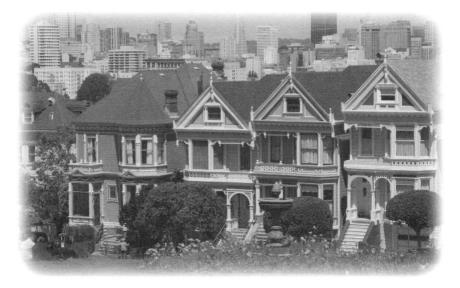

"Painted lady" Victorian houses face Alamo Square Park.

1850s, when it was a rocky hill with a lone poplar tree, the gracefully landscaped four-block park features curving pathways and stands of fragrant eucalyptus and pine trees. Plagued by neglect and deterioration in recent decades, the park has sprung back to life through volunteer efforts and a city-funded improvement plan. A new children's playground, picnic tables, benches, and flower plantings, along with a restored rose garden, make it a delightful place to take a midday break. The park's charms are not lost on stroller-pushing nannies, hand-holding couples, and dog walkers with multiple hounds on tether.

The park's southeastern grassy slope, with its cushion of tiny wildflowers in spring, remains the most popular spot for kicking back and soaking up the sun. From here, visitors have the best view past the Victorian peaked roofs and down to the gleaming cityscape beyond.

essentials

⬛	Bounded by Fulton, Hayes, Scott, and Steiner streets, San Francisco, CA 94117
☎	N/A
🌐	sfnpc.org/alamosquarehistory
$	Free
🕐	Open 24/7
🚌	**Muni bus:** 21, 22

peaceful place 3

ALLIED ARTS GUILD

Menlo Park (MAP NINE)

CATEGORY ↝ parks & gardens ✪ ✪

*T*ransport yourself to the gardens of Madrid or Seville with a visit to the Allied Arts Guild in Menlo Park. Set on a former historical land grant, this complex of shops, artist studios, and heavenly gardens is a delightful place for strolling, relaxing, and enjoying the open air in the old-world tradition. Since its inception in 1929, the guild has served as a working environment for local artists and as an auxiliary supporting what is now the Palo Alto–based Lucile Packard Children's Hospital.

The Moorish-style fountain is one highlight in the garden at the Allied Arts Guild.

Tucked away in an upscale neighborhood of elegant ranch-style homes and everything-grows-here horticultural abundance, the buildings are the work of leading Bay Area architect Gardner Dailey (1895–1967) and Oakland-based artist Pedro de Lemos (1882–1954). Designed in the Spanish Colonial style and commissioned by wealthy art patrons enamored of Spain, the property features red-tiled roofs, archways, interior court-yards, and decorative wrought iron.

Separate gardens, each with its own character, combine to form a lush oasis of blossoms, fruit, and fragrance. The color blue dominates one garden, where massive hydrangeas, Nile lilies, asters, and an arbor of Chinese wisteria border a patio and azure-tiled pool. Reminiscent of a Moorish orangery, another section features citrus trees, an effervescent fountain, and beds of marigolds, wallflowers, and nasturtiums. In a third space, a narrow allée of tree roses recalls the Generalife Gardens of the Alhambra in Granada, Spain.

Stop by for some shopping and a bit of light fare at the guild's Café Primavera. As you enjoy the grounds, picture Ansel Adams (1902–1984), who served as the Allied Arts photographer of record, capturing the gardens for posterity.

essentials

☰ 75 Arbor Road, Menlo Park, CA 94025

☎ (650) 322-2405; **Cafe** (650) 321-8810

🌐 alliedartsguild.org

$ Free; **Cafe menu prices:** $5–$18

🕐 Monday–Saturday, 10 a.m.–5 p.m.; additional hours in November and December: Sunday, noon–5 p.m. **Cafe:** Monday–Saturday, 11:30 a.m.–2:30 p.m.

🚌 N/A

peaceful place 4

ANGEL ISLAND STATE PARK

Belvedere-Tiburon (MAP EIGHT)

CATEGORY ⌇ day trips & overnights ✪

*W*hen Spanish explorer Juan de Ayala anchored off San Francisco Bay's largest land mass, he was inspired to name it Angel Island. Since then, the site has been a cattle ranch, Army post, prisoner-of-war detention center, missile base, immigration station, and military jumping-off point for soldiers returning from war in the Pacific. Named a state park in 1954, the island now attracts modern-day explorers whose getaway goals involve simply dropping anchor off the mainland for a day.

Reachable only by private boat or public ferry, Angel Island is a haven for hikers, cyclists, islophiles, and history lovers who want to discover its place in the West Coast narrative. Crowds often disembark during the peak summer season and flock to the visitor center. But no worries: You can find your own space. A network of trails traverses the hilly isle, which barely covers 1 square mile. Placid coves, stretches of sand, grassy slopes, chaparral, and wooded ridges all make for a pleasant trek away from the ferry landing. Among the trails, I confess to choosing the longer, but more moderate, Perimeter Road hike, a 5-mile circuit that reveals different vistas at every turn. More-intrepid trekkers can opt for a loop that takes them to Mount Livermore, the highest elevation. Trails are more peaceful in winter, though ferry service is less frequent. Spring treats you to a profusion of wildflowers, including blue forget-me-nots, golden California poppies, and red Indian paintbrushes.

Be sure to check the ferry arrival and departure times. The last departing ferries typically leave in midafternoon, and this is one boat you don't want to miss—unless you have secured a camping reservation and have come prepared for an overnight wilderness in one of the environmental (backpack) camping areas.

essentials

☰ Belvedere-Tiburon, CA 94920

☎ Park (415) 435-5390; **Blue & Gold Fleet** (415) 705-8200; **Angel Island–Tiburon Ferry** (415) 435-2131; reservations for environmental camping (800)-444-PARK (7275)

🌐 parks.ca.gov/?page_id=468; blueandgoldfleet.com; or angelislandferry.com

$ **Blue & Gold Fleet ferry** fares for a one-way ride (you'll need to buy two tickets): Adults (age 13 and up), $8; seniors age 65 and up and children ages 6–12, $4.50 **Angel Island–Tiburon Ferry** round-trip fares: Adults (age 13 and up), $13.50; children ages 6–12, $11.50; children ages 3–5, $3.50; children age 2 and under, free (one free child per accompanying adult); bicycle transportation, $1

🕐 Daily, 8 a.m.–sunset

🚌 **Ferry service from San Francisco:** Blue & Gold Fleet
Ferry service from Tiburon: Angel Island–Tiburon Ferry

peaceful place 5

ARLEQUIN CAFÉ AND FOOD TO GO

Hayes Valley (MAP THREE)

CATEGORY ✍ quiet tables ✪

The garden at Arlequin Café and Food to Go may not be entirely secret, but it still manages to be a quiet and welcoming extension of this easy-to-love cafe. On the ultrachic Hayes Valley shopping corridor, Arlequin is part of a threesome that includes Absinthe Brasserie and Bar, plus the Arlequin Wine Merchant. The cafe serves reasonably priced breakfasts, light lunch fare, a handful of hot entrees, refrigerated grab-and-go sandwiches, desserts, and strong espresso.

Reached through glass doors, the backyard retreat is removed from the bustle in the dining room and at the ordering counter, where service is friendly and unpretentious. The patio features small wrought-iron tables and chairs, all surrounded by trees and flowering shrubs. As providence would have it, heat lamps keep you warm, making the garden hospitable almost year-round.

Though less formal than its Absinthe sibling, Arlequin's kitchen turns out serious food. Two eggs any style, with home fries and toast, get a savory kick from rosemary and onion jam, and the optional sausage is house-made. Reinterpreted standards include a Reuben stacked with smoked pastrami, sauerkraut, and Thai "Russian" dressing, along with a rich mac and cheese that outdoes anything mom made. The pace here is laissez-faire, so there's plenty of time to have your Valrhona triple-chocolate *crème bavaroise* and enjoy it too.

essentials

☲ 384 Hayes Street, San Francisco, CA 94102

✆ (415) 626-1211

🌐 arlequincafe.com

$ **Menu prices:** $3.25–$12

🕓 Monday, 8 a.m.–7 p.m.; Tuesday–Friday, 8 a.m.–8 p.m.; Saturday, 9 a.m.–7 p.m.;
 Sunday, 9 a.m.–5 p.m.

🚌 **Muni bus:** 6, 47, 49; **Muni Metro:** F, J, K, L, N, S, T; **BART:** Civic Center Station

peaceful place 6

ASIAN ART MUSEUM

Civic Center (MAP THREE)

CATEGORY ✍ museums & galleries ✪

ounded on the belief that art opens the mind and awakens the heart, the Asian Art Museum provides an ideal backdrop for enlightenment. Buddhist teachings form a key theme here, and the galleries are laid out to trace the path of the religion as it spread through Asia long ago. In Gallery 16, look for *Seated Buddha,* one of the museum's most celebrated objects and the world's oldest-known figure of "the awakened one," dated AD 338.

The museum turns its gaze on the full spectrum of Asian art—17,000 objects spanning 6,000 years of art history and 40 countries. Curated with a sense of beauty and harmony, the galleries feature soft lighting and muted color schemes that highlight the individual pieces and soothe the viewer. I would be hard-pressed to name my favorite gallery, but it might be the treasury of tiny Chinese jade vessels, figurines, and pendants. You'll also see massive stone deities, intricate textiles, weaponry, paintings, and calligraphic works. Skip the hurried docent tours, free-admission Sundays, and community events. If you can grab some time on a Wednesday or Thursday afternoon, as I did, you'll have the galleries nearly all to yourself.

The Bodhisattva Avalokiteshvara (Guanyin) circa 1100–1200 is from The Avery Brundage Collection.

Beautifully adapted from the city's former main library, the building boasts vaulted ceilings, inverted skylights, and "glass curtain" walls. It also has a spacious second-floor loggia that's ideal for quiet conversation. Cafe Asia, the museum's casual eatery, will satisfy your cravings for rustic renditions of Asian cuisine, such as the vegetarian grilled tofu mountain salad or the Rangoon noodle soup with sweet-potato noodles. Wash it all down with some sake or a *Roji* pot of green tea.

◡ː essentials

| ✉ | 200 Larkin Street, San Francisco, CA 94102 |

☎ (415) 581-3500

🌐 asianart.org

$ Adults, $12; seniors age 65 and up, $8; college students with ID and children ages 13–17, $7. Free for museum members, children age 12 and under, and San Francisco Unified School District students with ID. Thursdays after 5 p.m.: all tickets, $5. Free on the first Sunday of every month. **Cafe menu prices:** $6–$12

🕐 Tuesday–Sunday, 10 a.m.–5 p.m.; extended hours every Thursday February–September until 9 p.m.; closed New Year's Day, Thanksgiving, and Christmas. **Cafe:** Tuesday–Wednesday and Friday–Sunday, 10 a.m.–4:30 p.m.; Thursday, 10 a.m.–3:30 p.m.; additional hours every Thursday February–September, 5–8:30 p.m.

🚌 **Muni bus:** 6, 9, 9L, 19, 71, 71L; **Muni Metro:** Civic Center Station; **BART:** Civic Center Station

peaceful place 7

AT&T PARK

China Basin (MAP TWO)

CATEGORY ⌣ urban surprises ✪

*T*hink of it as the crack of the bat without the roar of the crowd. That's what you'll get when you head out early to AT&T Park, game ticket in hand, to watch the San Francisco Giants at their batting practice. The gates open two hours before the Major League Baseball game's first pitch, giving ticket holders plenty of time to kick back and witness this ritualistic exercise before the place becomes a festival of black-and-orange–clad fans. For baseball followers, this can, indeed, be a kind of reverie.

Called "baseball's perfect address," the urban ballpark at Willie Mays Plaza offers modern amenities within a nostalgic setting that recalls old-time stadiums, such as Chicago's Wrigley Field and Boston's Fenway Park. In China Basin, on the city's southern waterfront, AT&T Park provides sweeping views of the San Francisco Bay area from almost every seat in the house.

Before heading to the stands, get in a winning mood at China Basin Park, a public open space at McCovey Point. Named for Willie McCovey, the Giants Hall of Fame slugger, the area offers a great place to stroll along the shoreline, enjoy a picnic, or take a "history walk" and check out the bronze markers that commemorate every Giants team from 1958 through 1999.

Then settle in for batting practice, when the home and visiting lineups stretch, take their practice swings, and get ready for the umpire's call to "Play ball!" Bring your glove and, for day games, your sunglasses. You may catch a foul ball or a long blast off the bat of a major-leaguer. Fortify yourself with a ballpark hot dog, some garlicky fries, a gigantic soda, or whatever else will sustain you through the upcoming nine (or more!) innings.

Now that you've had your breather, it's game time.

⌇ essentials

☰ 24 Willie Mays Plaza, San Francisco, CA 94107

☏ (415) 972-1800

🌐 sfgiants.com

$ Ticket prices for Giants games (or watching the practice from a stadium seat) can range from $12 for bleacher seating to more than $200 for field club. (Market pricing applies to all tickets, and rates can fluctuate based on factors affecting supply and demand. See Web site above for pricing and ticket details.)

🕐 Game times vary: 12:35 p.m., 12:55 p.m., 1:05 p.m., 4:05 p.m., 5:05 p.m., 6:05 p.m., and 7:15 p.m. Gates open and pregame activities begin two hours before the game.

🚍 **Muni bus:** 10, 30, 45, 47; **Muni Metro:** N, T; **BART:** to Muni Metro N or T; **Caltrain:** to Fourth and King train station; **AC Transit:** to Transbay Terminal; **Ferry service:** Alameda/Oakland Ferry Services (direct service to the ballpark for most games and to the Ferry Building at other times); Golden Gate Transit Larkspur Ferry (direct service to the ballpark for all games except weekday games during the day); dedicated Vallejo Ferry (direct service to the ballpark for all weekend games and Independence Day game); regularly scheduled Vallejo Ferry to Ferry Building (for weekday games); Baylink (return ferry service to Vallejo for weekday night games from the China Basin Ferry Terminal at the ballpark). The San Francisco Bicycle Coalition operates a secure bike-parking facility. (See Web site above for additional public-transportation details.)

peaceful place 8

BAKER BEACH
Richmond District (MAP SIX)
CATEGORY ⌇ outdoor habitats ✪

A more laid-back cousin of neighboring China Beach, this mile-long stretch of sand is ideal for strolling, jogging, and romping with your dog. From here, you can take in killer views of the Marin Headlands and that marvel of suspended animation, the Golden Gate Bridge.

A winter's day makes for strolling on Baker Beach, with Marin Headlands in the background.

The beach is also a great place simply to sit, build a sand castle, and watch the sea roll in. If you'd rather have your picnic in a shaded glen than on the shore, cross the small parking lot to the hillside grove of cypress trees. Here you'll find a smattering of tables and outdoor grills.

San Franciscans are eager to revel in a true California-beach experience and catch a few UV rays when they can. So expect crowds of sun-seekers any day that the legendary fog remains offshore and the city heats up. Winter and early spring are the best times to enjoy Baker Beach without the crowds. Then, the

skies may be overcast and the coastal breezes brisk, but you'll share the beach with just a few couples, families, and dog walkers.

Two caveats: Cold water and volatile waves make swimming here risky. And the northern section of Baker Beach hosts clothing-optional sunbathers, so stay clear if you want to avoid, shall we say, too much anatomical information.

⌣ essentials

✉	Battery Chamberlin Road, Presidio of San Francisco, CA 94129
✆	(415) 561-4323
🌐	parksconservancy.org or nps.gov/goga
$	Free
🕐	Open 24/7
🚌	**Muni bus:** 29

peaceful place 9

BATTERIES TO BLUFFS TRAIL

Presidio of San Francisco (MAP FIVE)

CATEGORY ⌣ outdoor habitats ❂ ❂

Established by Spain in 1776, the Presidio of California has often been called San Francisco's birthplace. After a long military history, this expanse at the southern end of the Golden Gate Bridge became a Historic Landmark District in 1962 and a national park in 1994.

Anchored by a former military post that's now a cultural hub, the urban parkland is a setting of striking beauty and environmental diversity. Its majestic landscapes range from sandy beaches and craggy coastal bluffs to oak woodlands, secreted meadows, waving grasslands, and captivating forests of pine, cypress, and eucalyptus trees. These open spaces boast a 24-mile network of trails, among them the new 0.7-mile Batteries to Bluffs Trail, established by the Presidio's caretakers in 2007.

This dramatic pedestrian trail traces the park's untamed western shoreline, allowing you to reach the ocean without having to scramble down the steep vertical bluffs. Beginning near a collection of historical seacoast fortifications (the trail's namesake military batteries), the route takes you over an elaborate wooden stairway that descends to the relatively remote, clothing-optional Marshall's Beach. Along the way, the trail zigzags past scrub vegetation and native wildflowers, then crosses a narrow footbridge that affords just enough room for a couple of people to sit, let the hikers go by, and lollygag for awhile. At the trail's halfway mark, a towering promontory with a lone bench provides a place to stop and take deep breaths. Get your fill of the view, an expanse of sun-spangled Pacific Ocean that stretches from the Marin Headlands and the Golden Gate Bridge south to China Beach.

essentials

[=] Langdon Court and Lincoln Boulevard, San Francisco, CA 94123

(℅) (415) 561-4323

(⊕) presidio.gov or nps.gov/prsf

$ Free

(🕐) Open 24/7, but recommended sunrise–sunset

🚌 **PresidiGo Around the Park Shuttle:** Stop 13

peaceful place 10

BAYLANDS NATURE PRESERVE

Palo Alto (MAP NINE)

CATEGORY ↙ outdoor habitats ✪ ✪ ✪

*Y*ou may not like to get your feet muddy, but the shorebirds and animals that inhabit the Baylands Nature Preserve in Palo Alto love it. Encompassing 1,940 acres of protected territory not far from the Bayshore Freeway, this basin of primordial earth includes some of the only

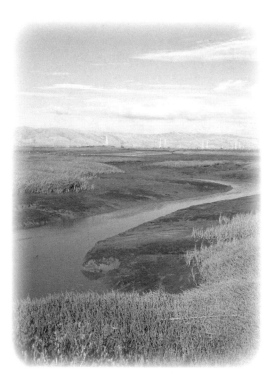

remaining salt-marsh and mud-flat habitats on the West Coast. Reaching inland from the southern branch of the San Francisco Bay, the Baylands' rich tidal and freshwater ecosystem (the largest of its kind in the Bay Area) consists of ponds and gently flowing sloughs that cut through thick colonies of salt-loving pickleweed and cordgrass.

The City of Palo Alto, which maintains the open space, has worked hard to preserve the tract of land from urban development, pollution, and agricultural lapses. In that effort, the municipality has plotted out 15 miles of multiuse trails around its periphery.

A rich ecosystem flourishes in the Baylands.

The 1-mile Marsh Front Trail, a bed of crushed oyster shells and decomposed granite, makes for an easy saunter around this undisturbed wetland, where you'll pick up the scent of brine and pungent vegetation. In the distance, waterfowl, such as the endangered white and black California least tern, quietly scavenge in the sediment for minute fish and crustaceans. The area is host to a remarkably high bird count, with owls, hawks, blackbirds, egrets, and night herons all living off the abundance of food and shelter. Bird calls break the stillness, and the occasional egret in flight provides an elegant spectacle.

You've probably seen this big bog from the air, when your plane was making its descent into San Francisco International Airport. Here's your chance to explore it firsthand.

essentials

🖃	Embarcadero Road, Palo Alto, CA 94303 (near Baylands Nature Center: 2775 Embarcadero Road)
☎	(650) 329-2506
🌐	cityofpaloalto.org
$	Free
🕐	Daily, 8 a.m.–sunset
🚌	N/A

peaceful place 11

BERKELEY ROSE GARDEN

Berkeley (MAP SEVEN)

CATEGORY ✎ parks & gardens ✪

*S*top and smell the roses. The Berkeley Rose Garden is just the inducement to slow down and inhale deeply. Built in the 1930s under the Works Progress Administration, this amphitheater in the northeast Berkeley hills contains 3,000 rosebushes and 250 varieties.

The garden features a crowning 220-foot-long redwood pergola draped with climbing blooms. Noted Bay Area architect Bernard Maybeck suggested the design for the pergola, as well as the series of steep semicircular steps and flower beds into which the

A redwood pergola surmounts a terraced amphitheater at the Berkeley Rose Garden.

garden descends. Powerfully fragrant and seductive, the blooms reach their peak of perfection in mid-May, the best time to visit. 'Fragrant Cloud', the name of one variety here, says it all. The colors of these hall-of-fame beauties—deep red, bright pink, orange, and yellow—also point to another of the garden's star attractions, an unmatched view of the San Francisco Bay and brilliant sunsets beyond the Golden Gate Bridge.

You won't have this retreat all to yourself, though. It's a favorite of lovers, passersby, rose fanciers, and anyone else in search of serenity and pleasure. Plenty of people come here to tie the knot, so avoid the weekend wedding parties. The proximity of a tennis court may also seem like a bit of a deterrent to quietude, but it doesn't take the bloom off this rose.

꒰ essentials

꒰	1200 Euclid Avenue, Berkeley, CA 94709
☎	(510) 981-5150
🌐	ci.berkeley.ca.us
$	Free
🕐	Daily, sunrise–sunset
🚌	**AC Transit bus:** 65

peaceful place 12

BIX

Jackson Square (MAP ONE)

CATEGORY 〰 quiet tables ✪

fter turning into the narrow Gold Street alley, you'll find the entrance to Bix under a simple neon sign. A miniature music note on this inconspicuous marker blinks its on-and-off welcome, announcing that there's jazz inside. You feel as if you're about to slip into a forbidden speakeasy.

This retro-inspired supper club, which features live jazz nightly, is as busy as you'd expect during Friday lunch and evening dinner hours. But head to Bix toward closing time, as a friend and I did one quintessential foggy night, and you'll find a surprisingly intimate spot for a nightcap. Cozy up to the mahogany bar and ask the white-jacketed mixologist to concoct a couple of classic libations—perhaps a sidecar or a Bix Manhattan. Partner your cocktails with some tiny burgers, cheese-and-onion sandwiches, oysters on the half shell, or other tasty bar fare.

The evening's live performance will be over, but the lush ballads that play in the background will provide pleasant liner notes to your evening. Bix's stylish interior—with its sweeping staircase, swanky mezzanine banquettes, and cruise-ship details—will also carry you away.

〰 essentials

📧 56 Gold Street, San Francisco, CA 94133 📞 (415) 433-6300

🌐 www.bixrestaurant.com

$ Monday–Thursday, 5:30–11 p.m. (bar opens at 4:30 p.m.); Friday, 11:30 a.m.–2:30 p.m. and 5:30 p.m.–midnight (bar menu: 2:30–5:30 p.m.); Saturday, 5:30 p.m.–midnight; Sunday, 5:30–10 p.m.

🕐 **Menu prices:** $9–$40 (Fare mentioned above ranges $10-$16.)

🚌 **Muni bus:** 10, 12; **Muni Metro:** Montgomery Street Station; **BART:** Montgomery Street Station

peaceful place 13

BOOK PASSAGE

Corte Madera (MAP EIGHT)

CATEGORY ✌ shops & services ❂

*W*hoever said that books are the quietest and most constant of friends must have had Book Passage in mind. At this time-honored store, you'll find plenty of literary companions, along with a lit-loving staff to help you get acquainted. As its name implies, this bibliophile's Mecca offers plenty of travel books to feed your getaway dreams. But it also carries top-selling fiction, poetry, spirited memoirs, cookbooks, and adrenaline-pumping thrillers.

The staff encourages browsing, so get comfy in one of the seats on the aisles. The light-filled space also houses a cafe, where a friendly barista indulges your caffeine cravings with an espresso or frothy latte. Book Passage's two adjacent shop fronts each open onto a small patio that offers table seating, views of nearby Mount Tamalpais, and a chance to bask in some of Marin County's finest weather. (One close friend, no longer in the Bay Area, used to come here on Sunday mornings, calling this space her church.)

A literary hub for more than 30 years, the store also hosts numerous author appearances, book signings, lectures, and writers' conferences. These lit crawls can take the noise level up a couple of notches, so plan your visit around them if you want a quieter atmosphere.

essentials

51 Tamal Vista Boulevard, Corte Madera, CA 94925

(415) 927-0960 or (800) 999-7909; **Cafe** (415) 927-1503

bookpassage.com

Free; **Book prices:** $8–$26 and up; **Cafe menu prices:** About $8.50

Monday–Sunday, 9 a.m.–9 p.m.; **Cafe:** Monday–Friday, 8 a.m.–8:30 p.m.; Saturday–Sunday, 9 a.m.–8:30 p.m.

Golden Gate Transit bus: 80

peaceful place 14

BRIX

Yountville (MAP TEN)

CATEGORY ⌣ quiet tables ✪ ✪

*B*rix has reached deep into the vintner's lexicon for its name, which refers to a
scale by which the sugar content in a solution—in this case, wine—is measured.
But the Napa Valley restaurant, which embraces a farm-to-table philosophy, doesn't have
to go far to source many of the ingredients for its meals. Just a few steps from the outdoor
dining terrace, 16 acres of flowers, vegetable gardens, citrus and fruit orchards, and vine-
yards provide a year-round supply of organic produce. A stroll through the garden reveals
raised beds and plantings of strawberries, tiny salad greens, herbs, French beans, Swiss
chard, and squash, along with bunches of blooms and native plants. The covered terrace,

Enjoy casual dining in the Brix gardens.

which looks out on this enchanting Eden and beyond to the Mayacamas Mountains, is one of the sexiest spots in the valley from which to enjoy the lush countryside.

The seasonally changing menu offers such starters as pristine oysters with mignonette or a garden salad of shaved carrot, avocado, and radish. Lunch items might include fresh asparagus soup and an apple-walnut carpaccio. (*Note to vegetarians:* This menu's carpaccio is a play on words, referring to thinly sliced apples cut in the manner of the traditional paper-thin beef. *Note to meat lovers:* You may prefer the ricotta-smothered burger.)

Dinner could kick off with roasted mussels and chorizo, followed by robust entrees such as porcini-rubbed New York steak. A wine list of 800 bottles, some of them hard to find elsewhere, matches the excellence of the food menu. On your way out, stop by the restaurant's wine shop and select a small-production varietal to enjoy with a romantic home-cooked meal.

Brix received some good buzz when it served as a host of the *Top Chef: Las Vegas* series. But now that the reality-TV cast and crew have moved on, the restaurant has settled back into its role as a destination of choice for locals and visitors who treasure its relaxing ambience.

⌣ essentials

7377 St. Helena Highway, Yountville, CA 94558

(707) 944-2749 brix.com

Menu prices range from $2 each for oysters with classic mignonette to $21 for the Spring Burger (lunch menu) and $38 for the porcini-rubbed New York steak (dinner menu); wines by the glass, $7–$30 (see Web site above for menus and additional pricing information)

Monday–Saturday, 11:30 a.m.–3 p.m. and 5–9 p.m., bar menu, 3–9 p.m.; Sunday, 10 a.m.–2 p.m. and 5–9 p.m.

N/A

peaceful place 15

BURLINGAME PUBLIC LIBRARY

Burlingame (MAP NINE)

CATEGORY ✌ reading rooms ❂ ❂ ❂

*P*atrons at the Burlingame Public Library need no shushing from the librarian to keep the noise down. The reading spaces here are so quiet that you could hear a pin—or a book—drop.

Dedicated to "providing a good read," this charming library offers its visitors a serene ambience in which to cozy up with a favorite novel, hit the textbooks, or research on the Internet. You can also explore the nearly 200,000 titles in print, audio, and other formats.

A throwback to the 1930s, when the building was constructed, the library charms you with its quaint Mission-style architecture, suburban green lawn, and corner location on picturesque Primrose Road. A remodel in the 1990s seamlessly brought the newer spaces together with the original main reference room, which features a magnificent wood-trussed ceiling. The delightful children's reading room, which also survived the refurbishment, reveals storybook murals and typically hosts local families sharing the joys of reading.

Smiling and helpful librarians welcome you, while cozy leather chairs, modern technology, an airy skylight, and plenty of nooks make this a delightful and nostalgic place to unlock the mysteries of the printed—or virtual—page.

✌ essentials

📧 480 Primrose Road, Burlingame, CA 94010 📞 (650) 558-7400

🌐 burlingame.org/library $ Free

🕐 Monday–Thursday, 10 a.m.–9 p.m.; Friday–Saturday, 10 a.m.–5 p.m.; Sunday, 1–5 p.m.

🚌 SamTrans bus: 46, 292, 390, 391, 397; Caltrain: Burlingame Avenue Station

peaceful place 16

CAFÉ CLAUDE

Union Square (MAP ONE)

CATEGORY ⌣ quiet tables ✪ ✪

aris meets San Francisco at Café Claude, a small bistro situated in a narrow alley just off Union Square. This longtime favorite is the perfect place to while away the time over a glass of pastis in true Gallic fashion and imagine that you're lunching on the rue de Rivoli.

Decorated with furnishings from a bygone Parisian cafe, the place features a zinc bar, mellow lighting, vintage dining banquettes, and a menu of inexpensive time-honored bistro plates. Something of an institution, it draws an animated crowd of businesspeople and shoppers at lunch. On Thursday through Saturday nights, dinnertime heats up with live jazz. *Après-midi* is your window of opportunity for that late lunch, impromptu meeting, or discreet rendezvous.

I stopped in at about 3 p.m. one rainy afternoon and lingered over a *salade niçoise*, a glass of wine, and some reading. The atmosphere was decidedly laid-back, and the service from the French waitstaff unhurried. A few other diners conversed quietly, and no one decamped until happy hour. To get the feel of a Parisian pavement cafe, take a seat on the outdoor patio. This area is sheltered from the street hustle, and heat lamps keep you toasty despite the cool San Francisco air.

⌣ essentials

🗐 7 Claude Lane, San Francisco, CA 94108 📞 (415) 392-3505 🌐 cafeclaude.com

$ Menu prices: $8–$17

🕐 Monday–Saturday, 11:30 a.m.–10:30 p.m.; Sunday, 5:30–10:30 p.m.; happy hour: Monday–Saturday, 4–6 p.m.

🚌 **Muni bus:** 2, 3, 30, 45; **Muni Metro:** Montgomery Street Station; **BART:** Montgomery Street Station

peaceful place 17

CALIFORNIA ACADEMY OF SCIENCES NATURALIST CENTER

Golden Gate Park (MAP SIX)

CATEGORY ↙ urban surprises ✪

A massive *T. rex* skeleton, a four-story tropical rain forest, digital technology that lets you explore the universe, and Penguins + Pajamas sleepovers for kids—these are just some of the attractions you'll find under one roof at the California Academy of Sciences in Golden Gate Park. But as an institution known for pushing the limits of science, the academy also has a Naturalist Center, where you can read up on the natural world.

Little scientists, students, and life-long learners will find educational resources on everything from aquatic biology to zoology, as well as a quiet place to pull up a chair to sit, study, connect, and converse. Children and their parents may request to examine specimens close-up, touch a brown-bear pelt, use Internet resources, and explore the natural world through stories, games, and crafts. Citizen researchers may also pick up kits to participate in fieldwork and contribute data that may be used for studies on such creatures as ants and invasive spiders.

Helpful staff at the Naturalist Center—often graduate students in the sciences—can also assist you in accessing information from the Academy Library. (*Note:* The library itself, and its adjacent reading room, are open only to academy staff, affiliated students, and volunteers. But members of the public with a legitimate research need may use the services by appointment.)

essentials

55 Music Concourse Drive, San Francisco, CA 94118

Naturalist Center (415) 379-5494
Academy Library (415) 379-5484

calacademy.org

Naturalist Center appointments: Free. Museum general admission: Adults, $24.95; seniors age 65 and up, students, and children ages 12–17, $19.95; children ages 4–11, $14.95; children age 3 and under, free

Monday–Saturday, 10 a.m.–5 p.m.; Sunday, 11 a.m.–5 p.m.; closed Thanksgiving and Christmas. Students, teachers, and the general public may visit the Naturalist Center by appointment without visiting the rest of the museum; to make an appointment, contact the center at the telephone number above.

Muni bus: 5, 7, 18, 21, 28, 29, 33, 44, 71; Muni Metro: N

peaceful place 18

CANTOR ARTS CENTER RODIN SCULPTURE GARDEN
Palo Alto (MAP NINE)
CATEGORY ∿ museums & galleries ❂ ❂

or Bay Area locals, visiting the B. Gerald Cantor Rodin Sculpture Garden is a little like being an American in Paris. The outdoor art gallery, which showcases 20 bronzes by French sculptor Auguste Rodin, evokes the public garden spirit in the City of Light, where the renowned artist exhibited his work in the late 1800s. The installation, part of the Cantor Arts Center (more formally known as the Iris and B. Gerald Cantor Center for the Visual Arts), consists of the largest collection of Rodin bronzes outside Paris. It forms part of a comprehensive teaching collection of nearly 200 works by the sculptor in bronze, plaster, ceramic, stone, and wax, displayed in the garden and throughout three interior galleries.

The garden showcases Rodin's *The Gates of Hell*, a monumental project that depicts a scene from *The Inferno*, the first section of Dante Alighieri's *Divine Comedy*. Nearby, *Adam*, *Eve*, and *The Kiss* invite your study. As a counterpoint to the emotional power of these works, the garden encourages carefree repose and is best enjoyed on weekends, when fewer people are on campus. A sloping lawn, curving pathways, and a stand of slender cypress trees create an inviting landscape. Children cavort, couples stroll, a few families unpack a picnic basket, and patrons sip lemonade at the center's nearby cafe. Along the garden's edges, shade trees and benches create spots for solitary visitors to read or enjoy the tableau from a distance.

essentials

☰⁰ 328 Lomita Drive, Stanford, CA 94305

✆ (650) 723-4177

🌐 museum.stanford.edu

$ Free garden and Cantor Arts Center entry; parking is free after 4 p.m. and
all day Saturday–Sunday

🕐 **Garden:** Open 24/7; **Cantor Arts Center:** Wednesday–Sunday, 11 a.m.–5 p.m.;
Thursday, 11 a.m.–8 p.m.

🚌 **Caltrain:** Palo Alto Station; **Stanford Marguerite Shuttle** (the university's free bus)
operates routes from Caltrain to multiple campus locations

peaceful place 19

THE CASCADES AT JOAQUIN MILLER PARK

Oakland (MAP SEVEN)

CATEGORY ⌣: urban surprises ✪ ✪

 he East Bay offers many spots from which to enjoy scenic vistas, but perhaps
none quite so satisfying and alluring as The Cascades in Joaquin Miller Park.
Constructed in the late 1930s under the Works Progress Administration project, The
Cascades is a series of waterfalls that tumble down a natural spillway of shale and
boulders, culminating in two formal fountains. Crowning the top of the cataract is the
Woodminster Amphitheater, a concrete Art Deco outdoor theater decorated with strik-
ing angular human-figure motifs.

 While this sylvan setting in the Oakland hills sees a lot of visitors on weekends, par-
ticularly in summer, it's refreshingly quiet in off-peak hours. Rambling stairways flank

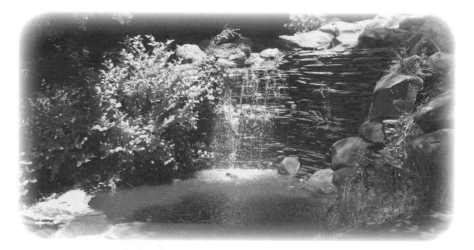

A cool cascade graces a park in the Oakland hills.

the waterfalls, creating ideal spots for reflection and shady respite among the native manzanita, acacia, and California redwoods that thrive in the park. Clearings in the tall evergreens, considered to be the only remaining second-growth redwood groves in an urban environment today, offer atmospheric views of the San Francisco Bay. Waterfall addicts (and everyone else) will also appreciate the relaxing tempo of this aqueous spectacle and its mist on a warm day.

Named for author Cincinnatus Hiner Miller (1841–1913), who adopted the pseudonym Joaquin and was known as the "poet of the Sierras," the parkland site of The Cascades still features thousands of trees planted under Miller's stewardship.

essentials

3300 Joaquin Miller Road, Oakland, CA 94602

(510) 482-7888

www.oaklandnet.com/parks

$ Free

Daily, sunrise–sunset

N/A

peaceful place 20

CHABOT SPACE & SCIENCE CENTER

Oakland (MAP SEVEN)

CATEGORY ↲ museums & galleries ✪

*I*t doesn't take rocket science to know a good museum when you see one. The Chabot Space & Science Center in Joaquin Miller Park is one in a galaxy of cultural offerings in the East Bay and a place that's guaranteed to expand your universe. If you're worried about encountering hordes of museumgoers and maintaining, well, your own space, there's a solution. Take one giant leap to the Ask Jeeves Planetarium, where everyone, from toddlers and kids to adults and seniors, sits immersed in spellbound wonder.

A state-of-the-art, 70-foot digital full-dome theater, the intimate auditorium invites you to venture into the dark, where moveable images of stars, planets, and other celestial bodies are projected onto a curving overhead screen. Float into the cosmos and deep relaxation, lulled by narrators who will educate you in the mysteries of black holes, the search for alien life, and the history of the telescope. Check the Web site for programming, so that you don't miss the astronomer-led, real-time Sky Tonight tours of the lustrous stars that are brightening the heavens on the evening of your visit. Finish off a nighttime tour with up-close-and-personal telescope viewing of current Bay Area sky conditions. In all, it's a stellar experience.

⌣ essentials

⌑ 10000 Skyline Boulevard, Oakland, CA 94619

☎ (510) 336-7300

🌐 chabotspace.org

$ Adults, $14.95; children ages 3–12, $10.95; museum members, free; discounts available (see Web site for more information)

🕐 **Regular hours:** Wednesday–Thursday, 10 a.m.–5 p.m.; Friday–Saturday, 10 a.m.–10 p.m.; Sunday, 11 a.m.–5 p.m.; last entry one hour before closing; closed Thanksgiving and Christmas. Open 10 a.m.–5 p.m. on Martin Luther King Jr. Day, Presidents' Day, Memorial Day, Independence Day, Labor Day, Veterans Day, and New Year's Day (see Web site above for summer, program, and telescope-viewing hours)

🚌 **AC Transit bus:** 339; **BART:** Fruitvale Station (limited weekday service to museum from BART's Fruitvale Station)

peaceful place 21

CHARLES FRANKLIN DOE MEMORIAL LIBRARY

Berkeley (MAP SEVEN)

CATEGORY ↙ reading rooms ✪✪✪

*E*nvisioned as a "city of learning," the University of California, Berkeley campus hosts many splendid buildings, including the Charles Franklin Doe Memorial Library. Named for its benefactor, this architectural showpiece is about as regal as a library can get. The work of prominent architect John Galen Howard (1864–1931), the granite Beaux Arts edifice that combines elements of Greek, Roman, and Renaissance styles is listed on the National Register of Historic Places.

A grand architectural detail decorates the historical landmark.

Known informally as the Doe Library, it houses the university's primary research collection. The building contains several gorgeous reading rooms, each with a distinct character. Be sure to look up when you enter because the ceilings will dazzle. Begin with a visit to the room named for San Francisco attorney and book lover Alexander F. Morrison. Located just inside the north entrance, this space is intended for recreational reading and browsing—no ponderous volumes here. Warm oak paneling, Oriental area rugs, upholstered armchairs, and stacks of fiction, poetry, and periodicals recall an inviting parlor.

Move on to the second floor's North Reading Room, which boasts a vaulted gilt-and-white coffered ceiling. Natural light, perfect for quiet study, emanates from countless windows and skylights. Next enter the Roger W. Heyns Reading Room, named for one of the university's chancellors. Here a chocolate-colored plaster-cast ceiling surmounts an expansive room of genteel, old-world warmth. If you didn't attend the university, the reading rooms might be inducement enough to enroll now.

⌐ essentials

Doe Library, University of California, Berkeley, CA 94720; **Visitor Services:** 101 Sproul Hall, Telegraph Avenue and Bancroft Way. (No single official address exists for the university, but for GPS navigation systems, use 2501 Bancroft Way, Berkeley, CA 92704.)

(510) 643-4331; **Berkeley Visitor Services** (510) 642-5215

lib.berkeley.edu

$ Free visit, without borrowing privileges

Library hours vary; check the Web site above for a calendar of dates and times when the library is open, or call Visitor Services

AC Transit bus: 1, 7, 51, 52; **BART:** Downtown Berkeley Station; **UC Berkeley Campus Shuttle** (Monday–Friday): bus service from Downtown Berkeley near BART station to campus perimeter, Botanical Gardens, and Lawrence Hall of Science

peaceful place 22

CHINA BEACH
Richmond District (MAP SIX)

CATEGORY ↙ outdoor habitats ✪ ✪

*W*hen a beach vacation to Barbados or the Mayan Riviera just isn't in the cards, consider a "staycation." China Beach, a sandy slice of paradise on the Pacific Ocean at the city's northwest edge, offers the perfect spot for an afternoon's getaway in your own backyard.

The tiny cove, sequestered below the charming Seacliff neighborhood, is a smooth curve of immaculate sand fringed by rocky cliffs. Legend has it that local residents named the strand for the Chinese fishermen who, long ago, anchored their boats and camped on the beach. Here you almost expect to find a message in a bottle as you comb your way along the shore. From this vantage point, you're also treated to gorgeous views of the Golden Gate Bridge and Marin Headlands across the bay. At low tide, you may get a close-up look at starfish, mussels, and colorful anemones that attach themselves to the cliffs.

The park service cautions against swimming here because of unpredictable surf and cold waters. But the cove—which is part of the Golden Gate National Recreation Area, also designated a national park site—offers a lovely spot for picnicking and a small deck for sun worshipping. While China Beach is lesser known than the city's other Pacific Coast beaches, you can expect to run into more people on warm, sunny days. Winter and early spring make great times for an undisturbed visit.

↙ essentials

🖃 Seacliff Avenue (at El Camino del Mar), San Francisco, CA 94121 ☎ (415) 561-4323

🌐 parksconservancy.org $ Free 🕐 Open 24/7

🚌 Muni bus: 1

peaceful place 23

CHINA CAMP STATE PARK

San Rafael (MAP EIGHT)

CATEGORY ↙ parks & gardens ✪ ✪

*T*he histories of land and people converge at China Camp State Park, a 1,512-acre open space on the north shore of San Pablo Bay. Originally settled by the indigenous Coast Miwok and later adopted by Chinese immigrants, the park features painterly vistas, miles of multiuse trails, and the remnants of a Gold Rush–era fishing village.

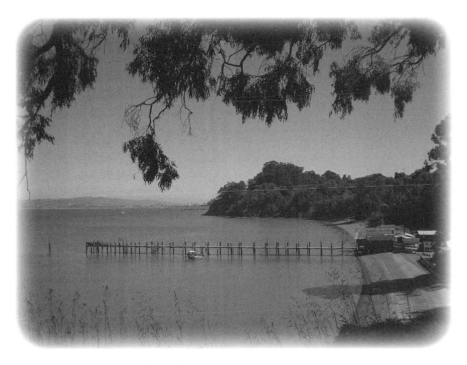

A quiet fishing village remains on San Pablo Bay.

Shoreline trails lead hikers, cyclists, and equestrians along seawater marshes that host waterbirds and grass shrimp. The wetlands open onto an expanse of placid bay water, where the occasional barge sits silently in the distance. Inland trails allow adventurers to meander through native grasslands, evergreen forests, chaparral, oak woodlands, and meadows that bloom with springtime lupines and buzz with chickadee songs. Anglers, campers, and kayakers will find plenty of diversions here too.

If your interests are more cultural than outward bound, be sure to visit China Camp Village. The old fishing enclave recalls the late 1800s, when Chinese laborers ran a shrimp-harvesting and export business here. A descendant of the last fisherman still lives at the camp, where a weathered pier, floating houses, a rickety shrimp-drying shed, and a small museum tell the story of a maritime enterprise that once supported 500 people.

The good news: the park boasts more than 200 sunny days a year. The caution: it's popular on weekends anytime except in the dead of winter. Be prepared to vie for the picnic spaces that dot the meadows and bay overlooks. It's better to head out on a weekday, when it's just you and Mother Nature.

essentials

| ≡ | 101 Peacock Gap Trail, San Rafael, CA 94901 |

📞 (415) 456-0766 🌐 parks.ca.gov/chinacamp $ Parking fee, $5

🕐 **General park hours:** Daily, 8 a.m.–sunset; day-use area closing times are posted at each location

🚌 N/A

peaceful place 24

CHINESE HISTORICAL SOCIETY OF AMERICA

Chinatown (MAP ONE)

CATEGORY ⌐ museums & galleries ⊕ ⊕

*H*oused in a landmark building designed by Julia Morgan, best known for her architecture of Hearst Castle, the Chinese Historical Society of America showcases one of the country's largest collections of Chinese American artifacts.

In this unassuming space—hardly the flashiest of San Francisco museums—a dragon figure welcomes you to the permanent gallery, and fresh flowers adorn the display cases. You can enjoy an undisturbed walk among the objects and photographs that trace the history and cultural legacy of the Chinese in America. The museum also highlights the many contributions that Chinese laborers made to the development of the American West's fishing, railroad, mining, and agriculture industries, as well as the racial oppression they faced on these shores. Their story unfolds through hundreds of items, including agricultural tools, mining implements, musical instruments, toys, postcards, and pop-culture ephemera.

Situated across the street from the Gordon J. Lau Elementary School, where, as a community volunteer, I once read stories to a new generation of Americans, the museum also focuses on teaching kids about their heritage and culture. It's fitting that Morgan's design abandoned the traditional elements that you see on Grant Avenue or Waverly Place, which depict the Far East as a fantasyland. We learn from one of the museum's exhibits that, while her 1932 building features some Chinese details, she invented a new San Francisco vernacular.

⌇ essentials

⌷ 965 Clay Street, San Francisco, CA 94108

☏ (415) 391-1188

🌐 chsa.org

$ Adults, $3; seniors and students with ID, $2; children ages 6–17, $1; children age 5 and under and members, free; admission free on the first Thursday of every month

🕐 Tuesday–Friday, noon–5 p.m.; Saturday, 11 a.m.–4 p.m.; closed Sunday, Monday, and holidays

🚌 **Muni bus:** 1, 30, 45; **Muni Metro:** Powell Street Station; **BART:** Powell Street Station; **Cable car:** California Street, Powell/Hyde Street, and Powell/Mason Street

peaceful place 25

CONSERVATORY OF FLOWERS

Golden Gate Park (MAP SIX)

CATEGORY 📖 museums & galleries ⊗⊗

*I*n a city resplendent with Victoriana, period architecture doesn't get much more elaborate than at the Conservatory of Flowers, Golden Gate Park's massive botanical greenhouse. Constructed in 1878, this "theater of nature" is the oldest municipal wood-and-glass observatory in America. Perched on a gentle rise, the domed white palace features thousands of windows framed by decorative woodwork. A city, state, and national historic landmark, the conservatory today houses 1,700 plant species and a renowned collection of high-altitude orchids.

photographed by Rachel Fong

A spiky bromeliad thrives in the gallery of aquatic plants.

When you enter this tranquil and ambrosial world, you're about to be let in on the secret life of plants. Work your way through the different rain forest galleries, beginning with the Lowland Tropics, where the ginger, coffee-berry, and fruit-bearing plants like it hot and humid. As you move into the Highland Tropics gallery, you're suddenly trekking in a Peruvian jungle, where cool mists swirl around you and hundreds of fragile orchids cling to backdrops of tree bark.

Not to be outdone, the gallery of aquatic plants beckons, with its giant water lilies—said to be strong enough to support a child's weight—and its popular special exhibit of carnivorous plants. While you won't see any of

A shade-loving peace lily takes center stage.

the fictionalized man-eaters that have populated Hollywood films since the 1960s, the conservatory's special exhibitions of pitcher plants from Borneo and the world's largest Venus flytrap never fail to inspire awe.

essentials

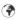 100 John F. Kennedy Drive, San Francisco, CA 94118

(415) 831-2090

conservatoryofflowers.org

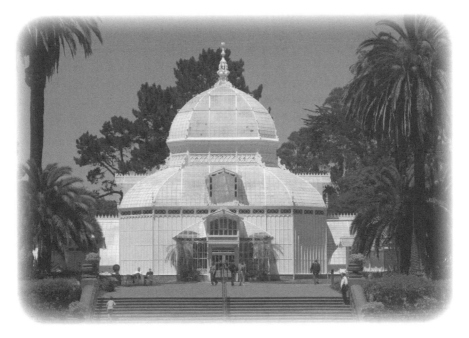

Golden Gate Park's domed white palace welcomes you.

$ Adults, $7; children ages 12–17, seniors age 65 and up, and college students with ID, $5; children ages 5–11, $2; children age 4 and under, free; admission free on the first Tuesday of every month; discounts available to San Francisco city and county residents with proof of residency

🕐 Tuesday–Sunday, 10 a.m.–4:30 p.m. (last admission at 4 p.m.); closed Monday, except Memorial Day and Labor Day; closes at 2 p.m. December 24

🚌 **Muni bus:** 5, 7, 21, 33, 44, 71; **Muni Metro:** N. **Seasonal Shuttle Service** connects locals and visitors to attractions across the 3-mile length of the park. (Fee is $2 for an all-day, round-trip pass; free for children under age 3 and for individuals with Americans with Disability Act needs. For more information, see Web site.)

peaceful place 26

CONTEMPORARY JEWISH MUSEUM

South of Market (MAP TWO)

CATEGORY ⌄ museums & galleries ✪ ✪ ✪

*W*hat's old is new again. At the Contemporary Jewish Museum, internationally renowned architect Daniel Libeskind has transformed the landmark Jessie Street Power Substation, designed in 1907, into a gathering place for the appreciation of all things related to Jewish culture, history, art, and ideas.

Reserve an afternoon for your exploration of this space, where exhibitions include vibrant and thought-provoking art projects, history lessons, and film, along with music, literary events, and other live performances. Its design inspired by the Hebrew phrase *l'chaim* ("to life"), the museum features a number of restful outdoor and gallery spaces. On a broad plaza, a shallow pool edged with small stones calms and restores your spirits as you sit on one of the nearby benches. Arrangements of boulders and grasses create a feeling of woodland openness. Atop a pedestrian walkway connecting Market and Mission streets, you'll witness the architect's surprising addition to the historical Beaux Arts substation: a massive cube paneled in brilliant blue steel, which contains an inner gallery space.

The museum's galleries give you a sense of community, no matter what your spiritual center. And most likely you'll experience diverse emotions. On one visit, I viewed a poignant exhibition of an artist's response to Adolf Hitler's *Mein Kampf;* a delightful history of recorded Jewish music set in a 1960s-style living room; and a reinvention of Jewish ritual in art and design.

↙ essentials

☰ 736 Mission Street, San Francisco, CA 94103

☎ (415) 655-7800

🌐 thecjm.org

$ Adults, $10; seniors age 65 and up and students with ID, $8; children age 18 and under and members, free; Thursdays after 5 p.m.: all tickets, $5

🕐 Monday–Tuesday and Friday–Sunday, 11 a.m.–5 p.m.; Thursday, 1–8 p.m.; closed New Year's Day, the first day of Passover, Independence Day, the first day of Rosh Hashanah, Yom Kippur, and Thanksgiving

🚌 **Muni bus:** 5, 6, 7, 9, 14, 14L, 16, 21, 31, 38, 71; **Muni Metro:** J, K, L, M, N, T; **BART:** Powell Street Station; **Golden Gate Transit bus:** 70, 73, 80; **SamTrans bus:** Transbay Terminal

peaceful place 27

CRISSY FIELD

Presidio (MAP FIVE)

CATEGORY ✒ outdoor habitats ✪

idal marsh, landfill, abandoned airfield, and rescued ecosystem—that's the short history of Crissy Field. Now a 100-acre shoreline park, this reclaimed wetland offers Bay Area residents a harmonious place to hike, bike, go for head-clearing runs, and watch dogs play in the surf.

Open to walkers, cyclists, and runners alike, a 1.5-mile promenade cuts past groves, sand dunes, and pristine beaches. A 20-acre tidal marsh sparkles along the pathway, and a broad green meadow cries out for kids to fly a kite. Get out your field guide and watch for cormorants, loons, and other water and wading birds. Turn slowly around for a 360-degree view of the Marin Headlands, Alcatraz, San Francisco, and the Golden Gate Bridge in all its international-orange glory.

Near the foot of the bridge, The Warming Hut bookstore and cafe serves up restorative

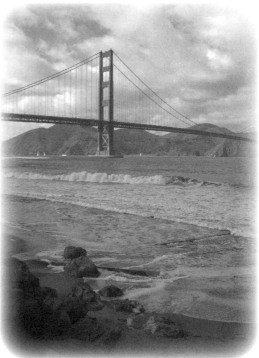

From Crissy Field, view the Golden Gate Bridge and Marin Headlands.

beverages and snacks. Welcoming but touristy, the shop has just a few tables. But if you have a free weekday morning, it's easy to grab a seat and gaze out over the surf, while enjoying a cup of the Hut's first-rate hot chocolate with whipped cream.

A caveat: While Crissy Field has room for everybody, fog-free days and the occasional heat wave draw people out in droves. One friend, a triathlete who trains here, recommends dawn or dusk for the most tranquil experience. Other fans, happy at the prospect of simply enjoying some wide-open space, remain undeterred by the parade of humanity.

essentials

▣ **Crissy Field Center:** 1199 East Beach, San Francisco, CA 94129
The Warming Hut: Presidio Building 983

✆ (415) 561-7690; **The Warming Hut** (415) 561-3040

🌐 crissyfield.org

$ Free; **Cafe menu prices:** $2–$20

🕐 Open 24/7; **The Warming Hut:** Daily, 9 a.m.–5 p.m.

🚌 **Muni bus:** 43; **PresidiGo Around the Park Shuttle:** several stops

peaceful place 28

DE YOUNG MUSEUM OBSERVATION DECK
Golden Gate Park (MAP SIX)
CATEGORY ⌣ scenic vistas ✪

*W*ith its special exhibitions showcasing the work of such luminaries as fashion designer Yves Saint Laurent and glasswork artist Dale Chihuly, the de Young Museum is a popular fine arts destination in Golden Gate Park. The museum, which now occupies a contemporary building that remedies the original property's seismic and structural problems, boasts excellent permanent collections of art from the Americas, Africa, and the Pacific.

To conform the new structure to the park's tree-filled environment, the architects cloaked the building in perforated and dimpled copper, which will take on a green patina with exposure to the elements over time. The designers also included a 144-foot, spiraling tower, which soars above the parkland's trees. All those enticements aside, the real pièce de résistance for tranquility-seekers is a trip up to the tower's observation deck. Worries will evaporate as you take in a 360-degree panorama of San Francisco, the greater Bay Area, the Golden Gate Bridge, and the craggy Marin Headlands.

From this vantage point, you also look out over the park's Music Concourse, an open-air plaza constructed at the turn of the century. The tower's deck also affords a close-up view of the pioneering California Academy of Sciences, with its "living roof" of seven gently rolling hillocks that form a habitat for native butterflies and other wildlife. Go early or late, and avoid the first or last week of popular special exhibitions.

✄ essentials

 50 Hagiwara Tea Garden Drive, San Francisco, CA 94118

✆ (415) 750-3600

🌐 famsf.org/deyoung

$ Adults, $10; seniors age 65 and up, $7; children ages 13–17 and college students with
ID, $6; children age 12 and under, free; admission free on the first Tuesday of every
month. Extra fees may apply for special exhibitions. Admission tickets to the de Young
include same-day general admission to the Legion of Honor (special exhibition fees
not included); Muni riders with a Fast Pass or transfer receive a $2 discount; members
of the Fine Arts Museums of San Francisco receive free admission to the permanent
collection and most special exhibitions.

🕐 **Permanent collections:** Tuesday–Sunday, 9:30 a.m.–5:15 p.m. (extended hours every
Friday mid-January–November until 8:45 p.m.); closes at 3:30 p.m. December 24 and
31; closed New Year's Day, Thanksgiving, and Christmas

 Muni bus: 44; **Muni Metro:** N

peaceful place 29

DIABLO VALLEY OVERLOOK

Clayton (MAP TEN)

CATEGORY ⌄ scenic vistas ✪ ✪

*I*f you were to rank the Bay Area's top ten vista points, the Diablo Valley Overlook on the eponymous mountain would be a surefire winner. At 3,200 feet, the promontory on the western slope is still below the touristy summit destination in Mount Diablo State Park, and it is a more tranquil spot from which to take in the jaw-dropping scene.

Whether you choose to go by car, on two wheels, or on two feet, the approximately 9-mile trip up the peak will require some patience and, for cyclists and hikers, endurance. The state-parks service acknowledges that the park today is oriented to cars, with a curving road that encircles the mountaintop and an initial maximum speed limit of 25 miles per hour that slows to 15 miles per hour soon after you get under way. However, from its base to its summit, the mountain offers a multitude of hiking trails. Several lead to the vicinity of the overlook but, remember, an outback excursion of this sort requires a full day's trekking, a serious consultation of Web site trail maps, and plenty of stamina. Another option for hikers is to reach the overlook by car and then take the 3.8-mile, moderately graded Juniper to Pioneer to Summit Loop along the western slope and up to the top.

No matter what your mode of travel, you'll see fascinating geological formations, springtime displays of wildflowers, and changing life zones of flora and fauna. Once you leave the lower elevations of oaks, grasslands, buckeye, and chaparral, you start to see more colonies of knobcone and foothill pines. High bluffs drop off into shaded canyons, affording you 360-degree views. Abundant protected wildlife flourishes in the state park. We saw large raptors, California ground squirrels, and black-tailed deer, but the parkland hosts everything from gray foxes and mountain lions to red-legged frogs and tarantulas.

The overlook, a broad pullout area near Juniper Camp, provides a sweeping westerly

vista of the Diablo Valley and the extended Bay Area, including the Golden Gate Bridge. Summer days are hot and hazy, so park rangers recommend spring, fall, and any day in winter after a storm for the best viewing.

◡ essentials

96 Mitchell Canyon Road, Clayton, CA 94517

(925) 837-2525

parks.ca.gov (see "Mount Diablo State Park") or mdia.org (Mount Diablo Interpretive Association)

$ **Day-use fees:** $10 per car; seniors age 62 and up, $9 per car (see Web site above for fees at selected entrances and for other park uses)

Daily, 8 a.m.–sunset

N/A

peaceful place 30

DONNA SEAGER GALLERY

San Rafael (MAP EIGHT)

CATEGORY ↵ museums & galleries ⊕

*W*hile many Bay Area art galleries have installed perpetual DJs, happy hours, live performances, and wine bars, the Donna Seager Gallery in San Rafael exudes a quiet sophistication and inviting elegance, without all the hipster excess. Situated in the charming and vibrant downtown San Rafael shopping district, this light and airy gallery focuses on the rich tradition of San Francisco Bay Area art, with additional contributions from artists outside the region. Exhibitions embrace a variety of media, from figurative painting and jewelry as fine art to ceramics, abstraction, and

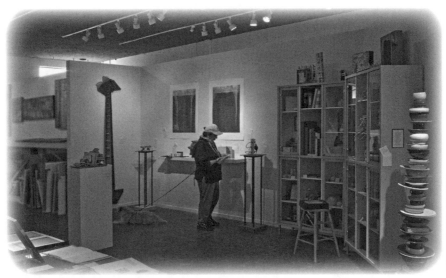

photographed by Jack Fulton

Donna Seager Gallery is a quiet enclave for browsers, collectors, and the community.

monumental sculpture, all beautifully curated. The gallery represents such acclaimed contemporary artists as painter Claudia Marseille, whose intelligent and richly layered works convey her deep respect for time and materials; sculptor Joe Brubaker, carver of fantastic figures from wood and mixed media; and abstract and figurative painter Devorah Jacoby, whose pieces expose the multiple layers of human interaction.

Owner Donna Seager is passionate about her gallery presentations and about creating a welcoming environment that enriches the collector's and community's experience. We stopped in to see the fifth annual installation of The Art of the Book, an exhibition of handmade books, altered books, and related works, which typically opens each May and lasts for a month or two. The exhibition encourages you to expand your thinking and consider the familiar printed volume as a medium for far-reaching art forms. Seager offered little disposable gloves so that we could touch the books, and she gave us her utmost attention so that we could better understand them. From this collection, she cited as peaceful the work of Jody Alexander, an artist and bookbinder who makes paper in the Eastern style and binds books with exposed sewing on the spine. Seager also drew our attention to an installation by Susie Grant: a beautiful pinned collage of birds made from discarded music-book covers. Whether you visit during an annual Art of the Book show or at other times, the gallery will inspire your own creativity.

essentials

851 Fourth Street, San Rafael, CA 94901

(415) 454-4229

donnaseagergallery.com

$ Free; prices range from $65 for small books to $10,000 for a grand-opus book. For other art pieces, prices range from $200 for small works to $15,000 for large paintings, with an average cost of $2,000–$10,000.

Tuesday–Saturday, 11 a.m.–6 p.m.

Golden Gate Transit bus: 42

peaceful place 31

ESTERO TRAIL TO DRAKES HEAD
Point Reyes National Seashore (MAP TEN)
CATEGORY ↙ day trips & overnights ✪ ✪ ✪

he Estero Trail, which hugs the edge of the Drakes Bay estuarial waters, is the ultimate off-the-beaten-path experience. Located in Point Reyes National Seashore parklands, the 9.4-mile trek requires some stamina and perseverance, but that makes the rewards feel all the more earned.

The trailhead sits about 25 miles from the Bear Valley Visitor Center and a short distance from Sir Francis Drake Boulevard. Adjacent to the trailhead, you'll find a small parking lot, a lone picnic table, and surrounding fields populated with Hereford cows. The bovine "wildlife" are likely to eye you with bemused curiosity as you set out on your journey.

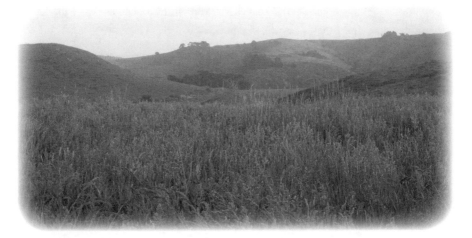

Open spaces beckon on the Estero Trail.

Staff at the National Park Service, which manages Point Reyes, consider the Estero Trail a popular ramble, but you'll find far fewer hikers here than on some of the other routes in this national seashore. On the pathway, you'll wend along the estuary shore through coyote brush, blackberry brambles, and pines. The area boasts an abundance of birds, among them countless plumed and skittering quail that spring into flight as you approach. You might also see rabbits, elk, and speckled deer. The trail is less defined toward the end, but plan for a refueling picnic when you arrive. You'll dine alongside superlative views of land and water, with leopard sharks visible below the estuary surface. And you'll be inspired to reflect while you rest up for the return trip.

One world-traveling friend considers Point Reyes National Seashore to be the most sublime and peaceful place on earth, so she advises that you check in at the Bear Valley Visitor Center for maps and tips on additional hiking in the area. If an overnight stay sounds appealing (and why would it not?), you'll find plenty of bed-and-breakfasts, inns, and lodges in nearby Olema, Inverness, and Point Reyes Station to accommodate you. (See also Limantour Beach, page 104.)

↙ essentials

Point Reyes National Seashore, Point Reyes Station, CA 94956

Bear Valley Visitor Center (415) 464-5100

nps.gov/pore for the national seashore; ptreyes.com for area lodging information

Free; various fees for nearby camping

Daily, 8 a.m.–midnight; **Bear Valley Visitor Center:** Monday–Friday, 9 a.m.–5 p.m.; Saturday–Sunday and holidays, 8 a.m.–5 p.m.; hours may be extended in summer

N/A

peaceful place 32

EUGENE O'NEILL NATIONAL HISTORIC SITE

Danville (MAP TEN)

CATEGORY ↙ day trips & overnights ✪ ✪ ✪

A wanderer for much of his life, playwright Eugene O'Neill (1888–1953) chose a 158-acre ranch near Danville as his refuge and final harbor. Drawn to the San Ramon Valley's temperate climate and pastoral native-oak landscape, the dramatist and his wife, Carlotta, created an insular home in the East Bay. Named Tao House, the couple's sanctum was inspired by his interest in Eastern thought and her love of Asian art and decor.

A four-time winner of the Pulitzer Prize and the only American playwright to receive the Nobel Prize, O'Neill completed six plays here, including the autobiographical plays that are considered his greatest works: *The Iceman Cometh, Long Day's Journey into Night,* and *A Moon for the Misbegotten.*

The grounds of this site in San Ramon Valley inspired playwright Eugene O'Neill.

As you tour Tao House, it's easy to see how the tranquil home provided the escape from public attention that the playwright required for his craft. A quiet palette of cool colors dominates the interior of the old ranch. The deep-blue ceiling is said to mimic the heavens, and dark hardwood floors represent the earth. Mirrors, Noh masks, guardian Foo dog statuary, Chinese lacquerware furnishings, and hundreds of books adorn the house, where jazz, reading, and poetry recitations were evening diversions.

Visit O'Neill's study on the upstairs floor, where the author used two desks, each facing bucolic views, to work on multiple plays simultaneously. The room, recalling a ship-captain's quarters, reflects O'Neill's early seafaring days and work as a crewman on a passenger line.

The national site is now closed to vehicle traffic, but periodic shuttle service is available to transport you here. Be sure to explore the grounds, where the O'Neills planted pine, almond, and redwood trees, and where the vistas encompass Mount Diablo and the Las Trampas Ridge. While health concerns forced O'Neill to eventually move from Tao House, the home was a steadfast muse that inspired his highest achievements.

essentials

Danville, CA 94526

(925) 838-0249

nps.gov/euon or eugeneoneill.org

Free visit and shuttle service

Wednesday–Sunday; advance reservations required all days except Saturday; shuttle service to site (see below) departs at 10 a.m., noon, and 2 p.m.; guided tours offered at 10 a.m. and 2 p.m. (allow two-and-a-half hours); closed New Year's Day, Thanksgiving, and Christmas

Vehicle access to the site is by National Park Service shuttle only. Shuttle departs from and returns to the Museum of the San Ramon Valley, 205 Railroad Avenue, Danville, CA 94526.

peaceful place 33

FARLEY BAR

Sausalito (MAP EIGHT)

CATEGORY 〰 quiet tables ✪

y the time I arrived at Farley Bar, a fine drizzle had begun to fall, eclipsing the view of San Francisco across the bay. The brooding weather cast the perfect backdrop for my visit to this snug and relaxed establishment at Cavallo Point, the luxury lodge that opened in 2008 at Fort Baker. Named for the popular *San Francisco Chronicle*

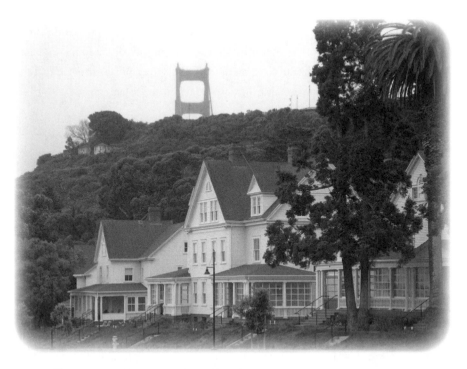

A military post turned luxury resort houses Farley Bar.

comic-strip character Farley, created by the late Phil Frank, the bar occupies a former barracks at this military post turned eco-resort. Specializing in creative cocktails and small-plate snacks, the dining spot features twin fireplaces, club chairs, a bar fashioned from a fallen tree, and framed cartoons by Frank, who was a Sausalito local.

The servers, who know a thing or two about hospitality, often suggest one of the inventive and seasonal house cocktails, such as Springtime, a surprising blend of cucumber vodka and kiwifruit. You may also choose from an extensive list of classic libations, wines by the glass and bottle, tasting flights, beers, and spirits. While the bar fare changes from time to time, it ranges from chilled asparagus salad and mussels with smoked-paprika butter to a grass-fed-beef burger with hand-cut fries.

Stop in for a late lunch or early dinner on a weekday, when your only compatriots will be a few locals and lodge guests. In less-inclement weather, enjoy your meal on the veranda, with its captivating vista of the Golden Gate strait. Monday nights make an especially cozy time to enjoy jazz and fireside cocktails in this quiet and intimate setting.

↵ essentials

601 Murray Circle, Fort Baker, Sausalito, CA 94965

(415) 339-4750

cavallopoint.com

$ House and classic cocktails, $12; snacks, $4–$17

Sunday–Thursday, 11 a.m.–11 p.m.; Friday–Saturday, 11 a.m.–midnight; snacks served Monday–Friday, beginning at 2 p.m., and Saturday–Sunday, beginning at 2:30 p.m.; live music: Monday, 7–9 p.m.

Muni bus: 76

peaceful place 34

FERRY PLAZA FARMERS MARKET

Embarcadero (MAP ONE)

CATEGORY ↙ shops & services ✪

A wildly popular food Mecca run by the Center for Urban Education about Sustainable Agriculture (CUESA), the Ferry Plaza market opens at 10 a.m. on Tuesdays and Thursdays and 8 a.m. on Saturdays. As the epicenter of the city's food trends, the market feels tremors of activity almost from the moment it opens. But that doesn't make its wares any less delicious or your visit any less enjoyable.

Tuesdays in winter make for the most jostle-free shopping experience. But try this tactic anytime: Arrive early for the soft opening, about a half hour before things officially get under way. The market occupies a broad sidewalk plaza, so there are no locked doors to keep you out. At this hour, regional farmers, ranchers, and artisans set up their tables of organic produce, farmstead cheeses, small-batch breads, dry-aged meats, and a cornucopia of other goods. While they are absorbed in this tantalizing activity, you can settle in with a cup of the town's tastiest java from the Blue Bottle Coffee kiosk on the building's west side. For an exhilarating view of the Bay Bridge and the morning mist rising on Treasure Island, linger over your coffee at one of the benches on the rear plaza.

Once the market opens, you can handily get your shopping done, even as the multitudes start to stream in. Sample liberally and think seasonally. In spring, you might snag tart cherries for a double-crust pie and, in summer, the perfect heirloom tomatoes for your gazpacho. With your purchases in tow, you can then head home for the ultimate culinary therapy: the joys of whipping up a feast.

essentials

[≡▪] One Ferry Building, San Francisco, CA 94111

(🖊) (415) 291-3276

(🌐) cuesa.org

$ Free; food prices vary

(🕐) Tuesday and Thursday, 10 a.m.–2 p.m.; Saturday, 8 a.m.–2 p.m.

(🚌) **Muni bus:** 1, 41; **Muni Metro:** F, N; **BART:** Embarcadero Station; **Cable car:** California
 Street; **Ferry service:** Golden Gate Ferry, Blue & Gold Fleet, and Baylink Ferries

peaceful place 35

FILBERT STREET STEPS

Telegraph Hill (MAP ONE)

CATEGORY ↙ enchanting walks ✪ ✪

*S*an Francisco is a city for the upwardly mobile. Situated on more than 40 hills, this urban landscape boasts hundreds of stairways that serve as conduits for getting up one side and down the other. Of these pedestrian pathways, the Filbert Street steps are among the most vertical—and the most lushly beautiful. Literally breathtaking after the ascent, the views from the summit and glimpses into a picturesque, historical neighborhood reward any trekker willing to make the climb.

The walkway heads straight up Telegraph Hill from Sansome Street, plateaus at monumental Coit Tower, and leads you down the western slope to North Beach. Street noises ebb away, and rooftops spread out below you. Sailboats bob in miniature on the bay. The route takes you over one of the city's few remaining wood-plank streets, where Victorian immigrant cottages

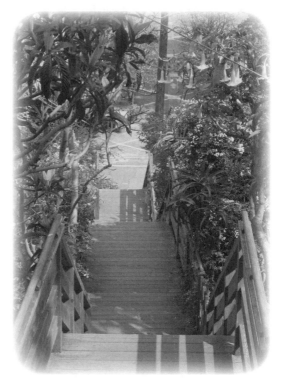

Lush gardens frame the Filbert Street steps.

still dot the hillside. A luxuriant Eden surrounds you—a paradise of perennials, shrubs, and fruit trees. Many were planted by resident Grace Marchant, who left her legacy on the hill. High above the trees, you'll hear the noisy chorus of the green-and-red wild parrots who have made Telegraph Hill a stopping point in their flight path.

Coit Tower rises above the historical stairway.

✓ essentials

Filbert Street between Sansome and Grant streets, San Francisco, CA 94133

N/A N/A

$ Free Open 24/7

Muni bus: 30, 39, 45; **Muni Metro:** F; **BART:** Montgomery Street Station

peaceful place 36

FILOLI

Woodside (MAP NINE)

CATEGORY ↵ parks & gardens ✪

*V*isitors often wonder about the origin of this historic estate's name. In a neat bit of wordplay, Filoli's founder, William Bowers Bourn II, tightly compressed key letters from his favorite credo: "*Fight* for a just cause, *love* your fellow man, and *live* a good life."

Fighting and loving aside, you certainly experience a sense of the good life when you stroll around the Filoli grounds. Now a private property of the National Trust for Historic Preservation, the estate encompasses a Georgian-style mansion, 654 acres of resplendent gardens, and 3,000 plant species—all surrounded by hayfields and oak woodlands. You can explore the mansion, but I recommend focusing on the outdoor terraces, pleasure gardens, and tree-lined allées.

Spring is the best time to witness nature's unfolding, when daffodils, pretty-in-pink magnolias, rhododendrons, and weeping cherry trees put on a showy parade. Toward summer, bowers of roses perfume the air with their fragrant top notes. And in autumn, ginkgo trees, scarlet-berried hawthorns, and Japanese maples display their beautiful foliage. Caution: avoid weekends and special-event days—especially in the height of spring—lest you encounter too many of your fellow men and women. Filoli is closed from late October through mid-February, when the gardens lie dormant and prepare for their spring reawakening.

Filoli's cafe serves salads, quiche, and sandwiches. So whenever you visit, you can enjoy a light lunch, with a view of the grounds from the conservatory-style dining room.

⌄ essentials

▣	86 Cañada Road, Woodside, CA 94062
☎	(650) 364-8300
🌐	filoli.org
$	Adults, $15; seniors age 65 and up, $12; students (ages 5–17) with ID, $5; children age 4 and under and members, free. Extra fees apply on special-event days. **Menu prices:** $3.50–$10.50
🕐	Tuesday–Saturday, 10 a.m.–3:30 p.m. (last admission 2:30 p.m.); Sunday, 11 a.m.–3:30 p.m. (last admission 2:30 p.m.)
🚌	N/A

peaceful place 37

FIRST CHURCH OF CHRIST, SCIENTIST
Berkeley (MAP SEVEN)
CATEGORY ⚘ spiritual enclaves ✪ ✪ ✪

escribed as "simply one of the great buildings of the world," Berkeley's First Church of Christ, Scientist is among Bernard Maybeck's masterpieces. Designed in 1910 by the prominent Bay Area architect, who also gave us the better-known Palace of Fine Arts in San Francisco, the church in 1977 earned National Historic Landmark status, the highest honor that may be bestowed on a building or site located within the United States.

The exterior of the First Church features graceful roof lines, columns topped by medieval figures, and a framework of pergolas dressed in twining wisteria vines. Visit in mid-April to see the profuse and exceptionally beautiful draping of velvety violet-blue and white blossoms, which perfume the corner on which the church sits.

Wisteria drapes the historical Berkeley church.

Said to be a creative fusion of architectural styles, the church is part Byzantine, Romanesque, Gothic, and Japanese in design. See if you can discern these styles as you study and appreciate this romantic building from an age gone by. Still host to a thriving and deeply spiritual congregation, the church is also open for tours at scheduled times to visitors who wish to admire the glories of its beautifully decorated interior as well as its magnificent facade.

⌄ essentials

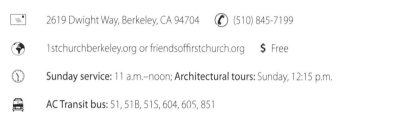

≡▪ 2619 Dwight Way, Berkeley, CA 94704 📞 (510) 845-7199

🌐 1stchurchberkeley.org or friendsoffirstchurch.org $ Free

🕐 Sunday service: 11 a.m.–noon; Architectural tours: Sunday, 12:15 p.m.

🚌 AC Transit bus: 51, 51B, 51S, 604, 605, 851

peaceful place 38

560 MISSION STREET
South of Market (MAP TWO)

CATEGORY 〰 parks & gardens ✪

*W*hen San Francisco's city planners asked for more public spaces in the South of Market area, architects answered the call. As part of a long-running revitalization, the neighborhood now boasts a mosaic of courtyards, gardens, and plazas that offer people places to relax, commune, and get off the grid. Of these parks, the one at 560 Mission Street is the jewel in the crown. Like many passersby, I did a double take when I discovered it.

Serving as the plaza of a glitzy 31-story office tower, the outdoor space occupies one-third of an acre on the busy Mission Street corridor. The park's most riveting feature—a jungle of gently arching giant bamboo plants—stands tall against an adjacent building, whose exterior wall has been painted in shades of red, forming a dramatic backdrop. A

A calming pocket park awaits Mission Street pedestrians.

pathway runs through the park and leads into the bamboo trusses. Stone ledges invite you to sit around a glassy reflecting pool and lean in to touch the water. A series of stepping-stones indulges you in your impulse to walk across the surface, while an installation of moving modern art transfixes your gaze.

For daytime use, the space is quietest during midmorning and midafternoon. The park's creators also want you to visit at night. They outfitted the place with fiber-optic lighting that guides you along the terraces and pathways. As public spaces go, it doesn't get more Zen than this.

⌣ essentials

📧 560 Mission Street, San Francisco, CA 94105

📞 (415) 982-6200

🌐 hines.com/property/detail.aspx?id=220 or 560mission.com

$ Free

🕐 Open 24/7

🚌 **Muni bus:** 14,14L; **Muni Metro:** Montgomery Street Station; **BART:** Montgomery Street Station

peaceful place 39

FORT POINT

Presidio (MAP FIVE)

CATEGORY ◡ˑ historic sites ✪

f you liked to play fort when you were a kid, here's a chance to channel those memories. Built by the U.S. military during the run-up to the Civil War, Fort Point stood vigil at the narrowest entrance of the San Francisco Bay. Soldiers stationed here waited for Confederate and foreign attack—enemies who never arrived. Later, when plans for the Golden Gate Bridge called for demolition of the fortress, creative engineering saved it. Designers added a soaring archway to the south approach of the bridge, just enough space to leave the fort intact below.

For a Golden Gateway panorama, climb the spiral staircase that leads to the platform tier on the roof. From underneath the arch, you can watch for approaching ships at sea, look across to the Marin Headlands, or gaze down at the bridge's

Fort Point's top platform affords a majestic view north.

south anchorage, where you might see a kite surfer or two riding the waves. Be prepared to take a bit of buffeting from the wind up here, where the air is typically about ten degrees colder than at ground level.

Visit in spring and fall to enjoy the best weather. But for greatest serenity, try a moody winter day, when harsher winds will keep almost everyone else exploring the military artifacts on the lower tiers. Perhaps you will recall the memorable films shot here, such as the classic one by suspense master Alfred Hitchcock. He surely appreciated the fort's atmospheric vibe. Some accounts say that Hitchcock commanded as many as 25 takes of the *Vertigo* scene in which Scottie (James Stewart) rescues Madeleine (Kim Novak) from the surf.

✧ essentials

⬜ Long Avenue and Marine Drive, San Francisco, CA 94129

📞 (415) 556-1693

🌐 nps.gov/fopo

$ Thursday–Monday, 10 a.m.–5 p.m.

🕐 Free, but donations accepted

🚌 **Muni bus:** 28; **PresidiGo Around the Park Shuttle:** Stop 17

peaceful place 40

THE GARDENER

Berkeley (MAP SEVEN)

CATEGORY ↝ shops & services ✪ ✪

\mathcal{G}imme shelter. Or, in the case of The Gardener, gimme things for my shelter. An institution since 1984, when it opened in a tiny Berkeley storefront, this shop satisfies the needs of backyard putterers and indoor homebodies alike. The proprietor of this store, a former garden designer and lecturer, recognizes that cultivating your garden is as much a state of mind (read: gracious living and peaceful ambience) as it is a matter of digging in the earth.

Now housed in a space three times the size of the original site, The Gardener also has branched out with stores at the Ferry Building in San Francisco and in Healdsburg, some 70 miles north. At the Berkeley location, you'll find a spacious retreat dappled with sunlight and stocked with everything from gardening gloves, design tomes, and culinary bibles to hand-hewn furniture and lawn chairs. Vases, ceramics, flatware, fragrant bars of soap, little potted succulents, and whimsical children's clothes are arranged pleasingly around the store, which is plotted out and furnished as elegantly as any strolling garden. It's no surprise that The Gardener's owner and creative force has another avocation, that of a photographer who brings a keen eye to her product sourcing.

Stop by on a Friday afternoon and gather things for your garden reverie—before the madding weekend crowd descends on Fourth Street, which has become a go-to shoppers' row.

⌣ essentials

☐ 1836 Fourth Street, Berkeley, CA 94710

☎ (510) 548-4545

🌐 thegardener.com

$ Free; merchandise prices vary

🕐 Monday–Saturday, 10 a.m.–6 p.m.; Sunday, 11 a.m.–6 p.m.

🚌 **AC Transit bus:** 51B

peaceful place 41

GARDEN OF SHAKESPEARE'S FLOWERS
Golden Gate Park (MAP SIX)

CATEGORY ↙ parks & gardens ✪ ✪

*I*f you're feeling as if your life's a bit too full of drama, find some peace and quiet in this Golden Gate Park nook. Respite lies adjacent to the California Academy of Sciences in the Garden of Shakespeare's Flowers.

Known more simply as the Shakespeare Garden, this shaded dell honors the plants, trees, herbs, and flowers that the Bard of Avon mentions in his poems and plays, often for symbolic effect. Designed in 1928 by the California Spring Blossom and Wildflower Association, the garden was a project of Alice Eastwood, who served as head of the academy's botany department until 1949 and who is memorialized on the garden's stone bench. The dell features a short brick-lined allée of crab apple trees that bloom in April and perfume the garden with their seductive scent. Bronze panels secured to a brick wall highlight plant-themed lines from Shakespeare's writings, with references to sycamores, fennel, columbines, nettles, oxlips, and violets. A tidy flower bed of other Shakespeare favorites, such as daisies, roses, and rosemary, also decorates the space.

The requisite bust of the world's preeminent dramatist is also here, stored under lock and key behind the brick wall and brought out for special occasions, such as wedding ceremonies (when the space is fully occupied and closed to the public). A large tree shades the garden, while benches encircle a lawn of soft grass, the perfect spot to throw down a blanket and pick up a copy of *Romeo and Juliet*. I even encountered a few student actors brushing up on the Bard's lines.

✐ essentials

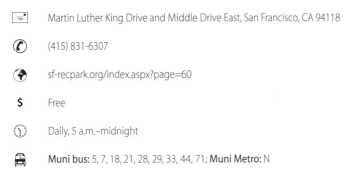

⊟ Martin Luther King Drive and Middle Drive East, San Francisco, CA 94118

☎ (415) 831-6307

🌐 sf-recpark.org/index.aspx?page=60

$ Free

🕐 Daily, 5 a.m.–midnight

🚌 **Muni bus:** 5, 7, 18, 21, 28, 29, 33, 44, 71; **Muni Metro:** N

peaceful place 42

GRACE CATHEDRAL LABYRINTHS

Nob Hill (MAP ONE)

CATEGORY ⌁ spiritual enclaves ✪ ✪ ✪

*T*he Dalai Lama, Archbishop Desmond Tutu, and Dr. Martin Luther King Jr. have all preached messages of peace at this San Francisco landmark atop Nob Hill. Often referred to as "the city's church," the Notre Dame–inspired cathedral offers visitors a place to pray, sit in the stillness, and seek refuge from the stresses of urban life.

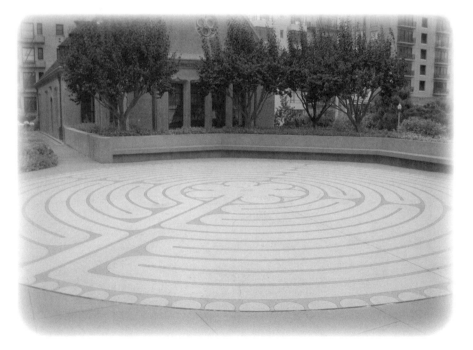

The outdoor stone labyrinth invites prayer and introspection.

Famed for its English carillons, poetic rose window, and bronze doors (cast from molds of 15th-century sculptor Lorenzo Ghibcrti's *Gates of Paradise*), the cathedral has also revived the ancient religious tradition of labyrinth walking. Here you'll find two labyrinths—divine imprints that symbolize the path to enlightenment. You can walk the indoor limestone pathway during cathedral hours, against a backdrop of incense, masterwork stained-glass windows, and choristers singing old Anglican music.

The outdoor labyrinth lies just to the right of the cathedral's imposing steps, at plaza level in the Interfaith Meditation Garden. This imprint, constructed of gray terrazzo stone, forms the garden's centerpiece. Delicate flowers and curved seating encircle this harmonious space, which encourages prayer and meditation, while offering more secular views of the Bay Bridge and the skyscrapers in the heart of downtown.

⌖ essentials

⊡ 1100 California Street, San Francisco, CA 94108

(𝄐) (415) 749-6300

(𝄐) gracecathedral.org (click on "Community" for information about the labyrinths)

$ Free

(𝄐) Sunday, 8 a.m.–7 p.m.; Monday–Friday, 7 a.m.–6 p.m.; Saturday, 8 a.m.–6 p.m.; **Outdoor labyrinth:** Open 24/7

🚌 **Muni bus:** 1; **Muni Metro:** Powell Street Station; **Cable car:** California Street, Powell/ Hyde Street, and Powell/Mason Street; **BART:** Powell Street Station

peaceful place 43

GREEN GULCH FARM

Muir Beach (MAP EIGHT)

CATEGORY ⌣ outdoor habitats ✪ ✪ ✪

ecades before sustainability evangelists adopted the word *green* as their own, Green Gulch Farm was already on the cutting edge. Operated by a branch of the San Francisco Zen Center, the farm shares space with a Buddhist monastery and meditation retreat. This thriving boutique agribusiness supports the center's spiritual aims, while advancing environmentally sound growing practices and sustaining itself financially through the sale of its organic produce.

You don't have to dig deep to experience the serenity at Green Gulch Farm. Situated on the Redwood Creek watershed, the center looks out over majestic Mount Tamalpais and Golden Gate National Recreation Area parklands. The garden, open daily, includes a series of "rooms" furnished with seating areas for contemplation and meditation. Footpaths wind through an array of hedges, rose arbors, fruit trees, and ornamental shrubs. Small

Rows of blooms are among the delights at Green Gulch Farm.

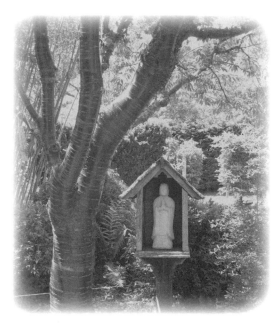

shrines along the pathways remind you of the garden's spiritual purpose and pay tribute to the divinity Jizo, a guardian of women, children, and travelers.

Past the nursery and greenhouses, the farm's vegetable beds and leafy fields of row crops stretch out toward the Pacific Ocean. You'll come away from Green Gulch with a deep appreciation of what it means to live on the land.

Shrines give the garden spiritual meaning.

✌ essentials

1601 Shoreline Highway, Muir Beach, CA 94965 ✆ (415) 383-3134

sfzc.org $ Parking fees may apply

Daily, 6 a.m.–sunset

N/A

peaceful place 44

HEADLANDS CENTER FOR THE ARTS

Sausalito (MAP EIGHT)

CATEGORY ↙ urban surprises ✪ ✪

\mathcal{L} ocated deep in the coastal wilderness north of the Golden Gate Bridge, the Headlands Center for the Arts may not seem like an urban venue. But the center's innovative mission and proximity to San Francisco tie it closely to city life.

Headlands, as the thriving center is called, hosts an internationally recognized Artist in Residence (AIR) program and rents studio space to local artists on a live-out

A site for the arts community thrives in a pastoral setting.

basis. Part laboratory and part public-art space, the center occupies nine artist-renovated military buildings in the Golden Gate National Recreation Area. The artists, whose work ranges from visual and literary pieces to performing arts and new media, find inspiration in their communal environment, as well as in the hills, cliffs, coves, and beaches that surround the campus.

While Headlands doesn't have a gallery, you can visit a working artists studio in the third-floor project space of Building 944 during AIR season. Imbued with a sense of history, the restored barracks is itself an art form, where stamped-tin ceilings, weathered benches, and timeworn implements honor the site's military past.

The center also brings artists and audiences together through conversations, open houses, exhibitions, and performances. Some events are for members only, but the general public is invited to participate in Mess Hall dinners and other celebrations, when you'll mingle with other arts patrons, if that suits your sense of peacefulness. During your visit, don't forget to walk around the grounds, where deer, coyote, hawks, and wild turkeys are often part of the landscape.

essentials

📧 944 Simmonds Road, Sausalito, CA 94965

📞 (415) 331-2787

🌐 headlands.org

$ Free; admission for some programs either free or range $15–$35, with discounts for members

🕙 Monday–Friday, 10 a.m.–5 p.m.; Sunday, noon–5 p.m.; closed on Saturday

🚌 **Muni bus:** 76

peaceful place 45

HESPE GALLERY

Union Square (MAP ONE)

CATEGORY ⌣ museums & galleries ✪

or gallery owner Charles Hespe, creating a high comfort level for both novice and established art collectors remains the primary objective, and you will benefit from his mission the minute you enter. The exhibition space sits just one block from hectic Union Square, among an enclave of venerable dealers. But you will ride a small elevator up four floors above street level to this gallery, where traffic and pedestrian noise is muted. There is little to distract you from complete absorption in the work of prized artists.

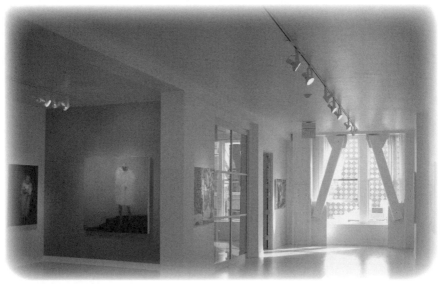

courtesy of Hespe Gallery

Hespe Gallery's uncluttered space does not compete with the art.

Enriching the experience, the white walls of this showroom display art to its best advantage. Soaring windows fill the space with light, and pale bamboo flooring adds to the easy, undemanding ambience. The space is quietest in summer, when Hespe and his staff have more time to pull out works not currently on display and to answer questions you may have about the carefully curated collection.

Notables on exhibition from time to time include Erin Cone, who produces portraiture of ethereal beauty. Her lone figures, typically of women in softly draped, muted clothing, can be transfixing. And Amberlee Rosolowich's totemic paintings of animals and children will bring a smile to your face.

You are in for a special nod to tranquility when the canvases of mixed-media artist Eric Zener adorn the walls—or if you ask to have them brought out. Zener's 14-by-21-inch *Summer Gliding Study*, for example, may hypnotize you with its depiction of a swimmer at one with the surrounding blue water.

But no matter which artist casts a spell over your afternoon, you will descend back to street level in a relaxed state of mind—ready to face the buzz of Union Square.

essentials

251 Post Street, Suite 420, San Francisco, CA 94108

(415) 776-5918

hespe.com

$1,000–$100,000 for artwork

Tuesday–Friday, 11 a.m.–5:30 p.m.; Saturday, 11 a.m.–5 p.m.

Muni bus: 2, 5, 6, 9; **Muni Metro:** F, J, K, L, N, T;
BART: Montgomery Street and Powell Street stations

peaceful place 46

HOOVER TOWER AT STANFORD UNIVERSITY

Stanford (MAP NINE)

CATEGORY ⌣ scenic vistas ✪ ✪

If you need to look at some sky, you can do it here. A major symbol of the Stanford University campus, the Hoover Tower rises 285 feet above the sprawling bastion of higher learning. Built in 1941, the classic moderne tower has a distinctive red-tiled roof and a carillon cupola that contains 48 weighty bells cast in Belgium. Named for U.S. President Herbert Hoover, a Stanford alumnus, the building houses a research institute founded by the former president.

The edifice also features a polygonal observation pavilion from which you can enjoy a serene and broad-brush view of the campus and the surrounding Santa Clara Valley. Cloud-free days are common, and the emerald foothills and red roofs below exaggerate the firmament. You'll also appreciate the beauty of the campus, where

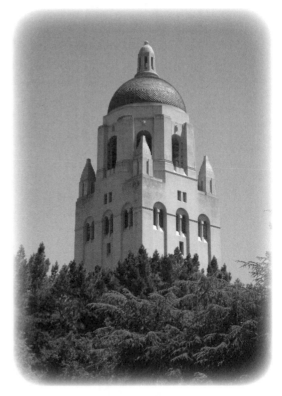

Hoover Tower rises over Stanford University.

rectangular missionlike buildings link to long arcades with arched doorways. So whether you're a student, parent, or visitor, ride the elevator to heaven—where you can think, dream, and take some deep breaths.

The popular landmark tower attracts numerous visitors, so time your visit for a weekend afternoon during the academic season, when you'll have the pavilion more to yourself. This is your room with a view, if borrowed for only a few minutes.

‿ essentials

🖃 Lasuen Mall and Crothers Way, Stanford, CA 94305

📞 (650) 723-2053

🌐 stanford.edu

$ Adults, $2; children age 12 and under and seniors age 65 and up, $1; Stanford students, staff, and family, free

🕐 Daily, 10 a.m.–4 p.m.; closed during academic breaks and final exams

🚌 Caltrain· Palo Alto Station; **Stanford Marguerite Shuttle** (the university's free bus) operates routes from Caltrain to multiple campus locations

peaceful place 47

JAPANESE TEA GARDEN AT CENTRAL PARK

San Mateo (MAP NINE)

CATEGORY ⌣ parks & gardens ✪

\mathcal{P}opular downtown San Mateo is highly urbanized, with apartment buildings lining the borders of its Central Park. You may still escape, however, thanks to the full acre devoted to this garden of serenity within the park. Designed in the 1960s by former landscape architect Nagao Sakurai of the Imperial Palace of Tokyo, the enchanting space remains remarkably sheltered. A circle of live oaks insulates the garden from the outside world.

In keeping with Japanese gardening traditions, the small landscape serves both as a sanctuary from daily stresses and as a strolling area that you must observe in detail to appreciate fully. Don't worry: You don't have to understand the gardening aesthetic at work here. Simply let your eyes rest on the many elements—waterfalls, stone basins, bridges, a koi pond, and a five-tier pagoda—that Sakurai artfully assembled to enlighten you and uplift your spirits. More than 70 varieties of trees, including classic flowering fruit trees and Japanese maples, provide spectacular bursts of pink, coral, chartreuse, and purple. Spring shows off the garden to best advantage but can draw more admirers. Autumn is a fine time to visit, with the maples in full regalia. A favorite of local families, the garden provides a lovely way to give children a little outdoor time, as well as teach them the joys of our horticultural world.

⌣ essentials

▣ 50 East Fifth Avenue, San Mateo, CA 94118

☏ (650) 522-7440

🌐 cityofsanmateo.org

$ Free

🕐 Monday–Friday, 10 a.m.–4 p.m., Saturday–Sunday, 11 a.m.–4 p.m.; koi feedings
during spring and summer, Monday–Friday, 11 a.m. and 3 p.m.

🚋 **Caltrain:** San Mateo Station

peaceful place 48

JOHN MUIR NATIONAL HISTORIC SITE

Martinez (MAP TEN)

CATEGORY ⤙ day trips & overnights ✪

" *In* every walk with nature, one receives far more than he seeks." This observation comes from naturalist John Muir (1838–1914), who is often called the "father of national parks." An immigrant, botanist, preservationist, trail walker, and writer, Muir spent the last 24 years of his life in Martinez, where he became a prosperous fruit rancher for five years before returning to his writing and conservationist pursuits.

Now part of the National Park Service itself, Muir's mansion and surrounding 335-acre grounds in the Alhambra Valley make for a good place to learn more about the cofounder of the Sierra Club and one of the world's most beloved nature writers. Take some time to visit the house, built in 1882, where Muir lived with his wife and two daughters in upper-middle-class comfort. Wander into his book-filled study—or scribble den, as he termed it—to see where he penned most of his environmental works. In front of the house, fittingly, a grand California bay tree shades the oval garden.

There's one distraction here: the proximity of a busy freeway, which most assuredly would not have delighted Muir. But, if you strike out on a hike deep into the parkland, you'll find that the hum of tires dissipates. Enjoy a stroll through pear and apricot orchards, citrus and walnut groves, coastal redwoods, and stands of native willows, buckeyes, elderberries, and oaks. All these living things gave inspiration to the man who said he never saw a discontented tree.

⌣ essentials

📧 4202 Alhambra Avenue, Martinez, CA 94553

📞 (925) 228-8860

🌐 nps.gov/jomu

$ Adults age 16 and up, $3 (good for seven days); children age 15 and under, free. Discounts, national park passes, and same-day-entrance access to selected national parks available (see Web site above for more details).

🕐 Wednesday–Sunday, 10 a.m.–5 p.m.; closed New Year's Day, Thanksgiving, and Christmas

🚌 N/A

peaceful place 49

JOSEPH PHELPS VINEYARDS

St. Helena (MAP TEN)

CATEGORY ↙ day trips & overnights ❍ ❍

A day of tasting in the Wine Country used to register as an escape. And, despite the crowds and traffic today, it still can. One place to go for some exceptionally serene sipping is Joseph Phelps Vineyards, in the Napa Valley, about 60 miles northeast of San Francisco. The winery's intimate, go-at-your-own-pace Terrace Tasting events make it easy to sample current releases in a casual, congenial setting, where guests are limited to six per party.

Known for its Rhône varietals and its flagship Bordeaux-style blend, Insignia, the redwood-timbered winery seems at once rustic and quietly refined. Situated atop a woodsy eastern foothill just off the Silverado Trail, the estate looks over the sun-dappled vineyards of Spring Valley and toward the Mayacamas Mountains. If the weather permits—and it does much of the year in this magical region—these guests-only gatherings take place on a trellised deck shaded by acacia trees and broad umbrellas. If the weather turns inclement, you retire to an indoor dining room.

Wine and conversation flow easily, as your Phelps hosts pour samplings of sauvignon blanc, chardonnay, pinot noir, merlot, zinfandel, and cabernet sauvignon. The final fillip is a luxe ice wine crafted from frozen grapes. On the day of our visit, bite-size chocolate-and-raspberry truffles accompanied this treat. A little hedonistic and a little heady, the Phelps tasting is the perfect way to inject some tranquility into your Wine Country experience.

essentials

 200 Taplin Road, St. Helena, CA 94574

(707) 963-2745

jpvwines.com

$ Four complimentary tastings per Terrace Tasting, with a Phelps Preferred Member ship; nonmembers, $25

Terrace Tastings are available by appointment only: Monday–Friday, beginning at 10 a.m. (last tasting beginning at 3:30 p.m.); Saturday–Sunday, beginning at 10 a.m. (last tasting at 2:30 p.m.). Weekdays tend to be more relaxed than weekends, and visiting on weekdays improves your chances of reserving one of the few rustic tables overlooking the vineyards, where you can enjoy a picnic after your tasting. **Winery hours:** Monday–Friday, 9 a.m.–5 p.m.; Saturday–Sunday, 10 a.m.–4 p.m.

N/A

peaceful place 50

KABUKI SPRINGS & SPA

Japantown (MAP THREE)

CATEGORY ⌣ shops & services ❸ ❸ ❸

*J*f you seek harmony and relaxation, consider the communal baths in this colorful and historical San Francisco neighborhood. While dozens of spas dot the Bay Area landscape, Kabuki Springs & Spa is an original—and the only one in the city to offer public baths in the Japanese tradition.

Heat (more and then less) is the signature agent in transporting you to a state of relaxation. Your bathing ritual calls for two sessions in a dry sauna or steam room, followed by a cool shower or a plunge into the cold pool. Kabuki keeps the pool at 55°F, guaranteeing an invigorating dip. After a brief resting period, you float out into a larger hot pool, your body and mind blissful. Conversation is low or nonexistent, contributing to the contemplative atmosphere that the spa seeks to provide.

Three days a week, the baths are open to women only. An alternating three days are for men only. Tuesdays are coed, with swimsuits required.

After the baths, if you haven't been pampered enough, the spa also offers soothing massages, energy balancing, body work, acupuncture, and body wraps of seaweed, ginger, or green tea. Any combination of these services is sure to gently cure what ails you.

⌣ essentials

☰˙ 1750 Geary Boulevard, San Francisco, CA 94115

℮ (415) 922-6000 ⊙ kabukisprings.com

$ Monday–Friday, all day, $22; Saturday–Sunday, all day, $25; use of communal baths with a treatment: $15; treatment costs vary, but Swedish massages or Balancing Facials are $85

⊙ Daily, 10 a.m.–9:45 p.m. 🚌 **Muni bus:** 38, 38L

peaceful place 51

LAKE MERCED
Sunset District (MAP SIX)
CATEGORY ⛰ outdoor habitats ✪ ✪

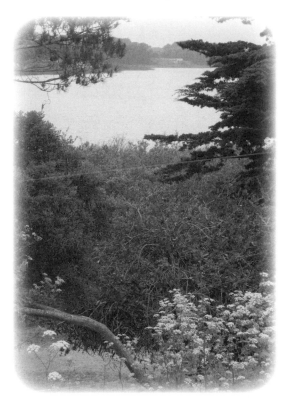
Native plants line the Lake Merced shore.

*W*henever you're determined to get off the couch or Sparky needs a workout, head to Lake Merced, a surprisingly bucolic setting in the city's southwest corner. One of three remaining freshwater lakes in San Francisco, Lake Merced is actually a cluster of four distinct but adjoining bodies of water. A 4.4-mile uninterrupted paved pathway traces the perimeter, making the urban wetland a popular destination for walkers, runners, cyclists, and their canine companions. Hailed as the best place for lake-boating in the city, this municipal parkland also features good picnicking spots and improved opportunities for shore fishing, now that the waters have been restocked with rainbow trout. Extended daylight hours bring out more fans, but you can enjoy a recreational idyll here any time of the year.

Formed by the Ice Age, Lake Merced is as much a critical ecological community as it is a recreational destination. Bird-watchers take note: As the largest freshwater wetland between Point Reyes to the north and Pescadero Marsh to the south, the site serves as a permanent home or a migratory refueling point for some 200 bird species.

Though most of the lake and its uplands are surrounded today by massive golf courses, residential neighborhoods, and several educational campuses, the area is also fringed by large stands of conifers, eucalyptus trees, toyons, and coast live oaks. To the west is the aptly named Pacific Ocean, making this a halcyon place to escape.

✎ essentials

▤ 1 Harding Road, San Francisco, CA 94132

✆ (415) 831-6328

⊕ sf-recpark.org/index.aspx?page=2405

$ Free for day-use. Additional fees for fishing, boat rental, and private boat launch.

⊙ **Circuit path:** Open 24/7; **Lake use:** 6 –6:30 a.m. to 5 –8:30 p.m., depending on the month, to coincide with daylight hours

🚌 **Muni bus:** 18

peaceful place 52

LEGION OF HONOR JACQUELINE AND PETER HOEFER STUDY ROOM

Presidio (MAP FIVE)

CATEGORY ⤷ reading rooms ✪ ✪ ✪

*I*f you have a passion for the graphic arts, come to the Jacqueline and Peter Hoefer Study Room at this Beaux Arts–style museum overlooking the Pacific. Here you can explore the most comprehensive collection of art on paper in the western United States. Maintained by the Achenbach Foundation for Graphic Arts, the works occupy the Hoefer Study Room on the museum's terrace level, tucked away from the heavily trafficked exhibition galleries.

You may quietly review its treasury of posters, rare books, 19th-century photography, and Japanese prints and drawings—more than 100,000 works spanning 500 years. The visually arresting Legion of Honor, bequeathed to the city by philanthropist Alma Spreckels, is a sublime place to pursue these studies. Located on windswept Lands End, the building is an adaptation of the 18th-century Palais de la Légion d'Honneur in Paris. A bronze cast of Auguste Rodin's *Thinker* welcomes you as you enter.

⤷ essentials

☰ 100 34th Avenue, San Francisco, CA 94121 ☏ (415) 750-3676

⊕ famsf.org/legion or achenbach.org/general.html

$ Adults, $10; seniors age 65 and up, $7; children ages 13–17 and college students with ID, $6; children age 12 and under, free; admission free on the first Tuesday of every month. See page 53 (de Young Museum Observation Deck) for more fee information.

⊙ By appointment, Tuesday–Friday, 10 a.m.–4 p.m.; open some Saturdays without an appointment (call ahead for hours); closed New Year's Day, Thanksgiving, and Christmas

🚌 **Muni bus:** 2, 18, 38

peaceful place 53

LETTERMAN DIGITAL ARTS CENTER

Presidio (MAP FIVE)

CATEGORY ᴥ parks & gardens ✪ ✪

*Y*ou wouldn't expect to find tranquility at a world-class institution devoted to the production of motion pictures, visual effects, and gaming technologies. But at the Letterman Digital Arts Center, in the Presidio of San Francisco, 17 acres are dedicated to public open space and designed to invite pedestrians into the pastoral setting.

Home to media giant Lucasfilm, creators of the *Star Wars* universe, the campus now occupies the site of a former parking lot and a shuttered military hospital that was named for Major Jonathan Letterman. (The U.S. Army commanded the Presidio from 1846 to 1994, when it became a national park site.)

The Letterman center looks like a part of the original Presidio facility, with a serene design created by renowned landscape architect Lawrence Halprin. A

A tranquil lagoon provides a spot for reflection.

palette of red brick, white stucco, and terra-cotta brings the new buildings into harmony with the older structures of the Presidio's military period. From the site, view corridors open out toward the Palace of Fine Arts, the Golden Gate Bridge, and San Francisco Bay. But it's the lush grounds that provide the greatest allure. Rolling green lawns, hundreds of newly planted trees, winding walkways, and the requisite Yoda sculpture transform this business center into a gardenlike environment. A tumbling creek and calm lagoon block traffic noise and restore your spirits in the way that Halprin intended. After work and on weekends, the setting is idyllic, with just a few people basking in the sun or lingering over coffee.

↝ essentials

⊞ Letterman Drive, San Francisco, CA 94129

𝓒 N/A

🌐 lucasfilm.com

$ Free

🕧 Open 24/7

🚌 **Muni bus:** 30, 41 (peak hours only), 43, 45

peaceful place 54

THE LIBERTY CAFÉ

Bernal Heights (MAP TWO)

CATEGORY ∿ quiet tables ✪

*E*picurean trends will come and go (molecular gastronomy—here now, passé tomorrow?). But comfort food will always be a draw, and the owner of The Liberty Café knows that very well. The restaurant's savory chicken and vegetable potpies have become the stuff of legend, and they've almost single-handedly put the outlying neighborhood of Bernal Heights on the culinary map. While leaning toward homey classics, including buttermilk waffles, corned-beef hash, BLTs, and mashed potatoes, the kitchen executes every dish with refinement and frequently indulges in flights of fancy. A bakery on the premises turns out a long list of specialties, including herb-flecked biscuits, scones, turnovers, berry tarts, and French macaroons. Everything is made from ingredients provided by local purveyors and growers who practice sustainable agriculture.

Not surprisingly, the ambience itself is every bit as heartwarming as the food. This cozy cafe on Cortland Avenue, where corner bookstores, small markets, and petite boutiques create a Main Street feel, features about a dozen white-linen-covered tables. The decor is a bit rustic, with hardwood floors, wooden chairs, and antique cupboards sharing the space. Popular for weekend brunch and at dinner on Friday and Saturday nights when a wine bar is also open, the place takes on a quiet intimacy on late weeknights. Stop by then, because you won't want to rush your meal of, say, wild-salmon crab cakes, lime-and-cumin-marinated tiger prawns, or pork chops stuffed with fontina and prosciutto—along with your selection from the list of mostly California wines. In a city of clamorous eating places, The Liberty Café is quite liberating.

⌣ essentials

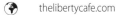

✉ 410 Cortland Avenue, San Francisco, CA 94110

☎ (415) 695-8777

🌐 thelibertycafe.com

$ **Menu prices:** $8 –$24

🕐 Tuesday–Friday, 11 a.m.–3 p.m. and 5:30–9 p.m.; Saturday–Sunday, 9 a.m.–3 p.m.
(brunch) and 5:30–10 p.m. **Bakery:** Tuesday–Friday, 7 a.m.–3 p.m., and Saturday–
Sunday, 7:30 a.m.–3 p.m. **Wine bar:** Thursday–Saturday, 5:30–10 p.m.

🚌 **Muni bus:** 24, 36; **Muni Metro:** F, J

peaceful place 55

LIMANTOUR BEACH
Point Reyes National Seashore (MAP TEN)
CATEGORY ↙ day trips & overnights ✪ ✪ ✪

Although the Point Reyes National Seashore boasts about 80 miles of shoreline, you can get to most of it only by trail or boat. Limantour Beach is, happily, one exception. About an hour's drive from San Francisco, this long spit of pale sand lies wedged between Limantour Estuary and Drakes Bay. As drives go, this one's a beauty, with stretches of deep redwood forests that hardly see sunlight giving way to coastal foothill grasslands.

Over a little crest of dunes, you'll find a postcard-worthy beach that's sheltered from the winds and backed by coastal bluffs at the southern end. This stretch of sand offers up a lot of space with surprisingly few people. Those who know of it accord it favorite-beach status. You'll find plenty of opportunities for picnicking, wave watching, and some carefree beachcombing. The strand also boasts big sunset views and some of the best bird-watching at the national seashore. Situated on the Pacific Flyway, the coastline and estuary host flocks of shorebirds that wade and feed at water's edge. In spring, gray whales tend their calves along the shore, and the year-round harbor seal residents take to basking beachside in the sun.

No lifeguards are on duty, so be mindful of the hazards that the ocean and beaches present. Stop by the park's Bear Valley Visitor Center for some guidelines. When you're ready to call it a day, you can wend your way back home—or not. You might want to plan an overnight at one of the many quaint inns and lodges in nearby Olema, Inverness, or Point Reyes Station. (See also Estero Trail to Drakes Head, page 58.)

✐ essentials

📧 Point Reyes National Seashore, Point Reyes Station, CA 94956

📞 **Bear Valley Visitor Center** (415) 464-5100

🌐 nps.gov/pore for the national seashore; ptreyes.com for area lodging information

💲 Free; various fees for nearby camping

🕐 Daily, 8 a.m.–midnight; **Bear Valley Visitor Center:** Monday–Friday, 9 a.m.–5 p.m.;
 Saturday–Sunday and holidays, 8 a.m.–5 p.m.; hours may be extended in summer

🚌 N/A

peaceful place 56

LOCH LOMOND RECREATION AREA

Felton (MAP TEN)

CATEGORY ⌇ day trips & overnights ✪ ✪ ✪

L och Lomond is a landscape just made for disappearing to the edge of the universe. Deep within the Santa Cruz Mountains, about 80 miles south of San Francisco, this recreation area is so big on nature and far enough from civilization that you might just spend the entire day here without running into a soul.

A sparkling reservoir cuts through a slash of canyon, hugged by a forest of young redwoods, Douglas firs, madrones, and live oaks. Because this is a drinking-water

photographed by William Craumer

Verdant nature surrounds pristine Loch Lomond.

supply, swimming isn't allowed and no gasoline-powered boats are permitted on the lake. So there's little sound in this remote fantasy woodland except that of your own footfalls.

You can, however, idle the day away by piloting a paddleboat across the water and enjoying a secluded picnic for two on tiny Clar Innis island. Your own private idyll might include casting a line and hoping for a nibble from some bluegill or largemouth bass. If you want to strike out on a leisurely hike, hit the tracery of dirt paths that follow the shore or lead up to the ridgeline. Take advantage of the wildlife-spotting and birding opportunities in this woodland, where deer forage, pond turtles laze in the shade, and ospreys circle above the lake looking for fish. Or give your boots a rest, park yourself on one of the shoreline benches, and simply recharge your mind.

GPS will be a valuable companion in helping you find your way to Loch Lomond. Once here, you'll relish the blissful isolation, which is entirely worth the drive.

essentials

🖃	100 Loch Lomond Way, Felton, CA 95018
☎	(831) 420-5320
🌐	cityofsantacruz.com/index.aspx?page=430
$	$4
🕐	March 1–mid-October: Daily, 7 a.m.–sunset
🚌	N/A

peaceful place 57

MACONDRAY LANE
Russian Hill (MAP ONE)
CATEGORY ↙ enchanting walks ✪ ✪

or his popular literary saga *Tales of the City*, San Francisco author Armistead Maupin reputedly drew inspiration from Macondray Lane, a magical and beloved path on Russian Hill.

Recast as Barbary Lane in Maupin's fictional account of San Francisco in the late 1970s and early 1980s, the pedestrian passageway is perhaps the most famous of the numerous corridors that cut through the hill's summit. Despite its renown, you can take a solitary and leisurely stroll along two-block Macondray Lane, even on a Saturday afternoon. Most tourists on Russian Hill are busy elsewhere— probably photographing nearby crooked Lombard Street, legendary for its hairpin turns.

A trellised entryway off Leavenworth Street admits you to the lane, where cottages,

A stone path and wooden stairs lead to Macondray Lane.

homes, and flats face off against a steep wall of rock and dense vegetation. Goldfish ponds, birdhouses, and tiny melodious waterfalls mingle with ferns, flowering shrubs, and old-growth trees. You may even encounter some of the locals, who cultivate the lane's gardens in a neighborly spirit. They'll appreciate your respect for their privacy. The shady brick-and-cobblestone lane culminates in a wood-plank stairway at Taylor Street, from which you can enjoy views, views, and more views of the bay.

essentials

Bounded by Leavenworth, Taylor, Union, and Vallejo streets, San Francisco, CA 94133

N/A

rhn.org

$ Free

Open 24/7

Muni bus: 41 (peak hours only), 45; **Cable car:** Powell/Mason Street

peaceful place 58

MECHANICS' INSTITUTE LIBRARY

Financial District (MAP ONE)

CATEGORY ↙ reading rooms ⊕⊕

*S*everal of my friends consider the Mechanics' Institute Library to be one of San Francisco's most tranquil spots. Located in the Financial District, the institute was founded in 1854 to boost local industry in the post–Gold Rush economy.

The library's neoclassical reference rooms occupy two airy and welcoming floors of the institute's historic landmark building. The open stacks offer a glimpse of the 160,000 books, periodicals, and audiovisual materials on subjects ranging from art and music to history, philosophy, and finance. Contemporary leather armchairs, arranged in cozy groupings around traditional wooden tables and desks, invite you to settle in for a good read. High-speed and wireless Internet access add some 21st-century capabilities. Large windows admit plenty of light, while potted plants and pale-hued walls create a restful ambience—the perfect retreat from your office, classroom, or city errands.

You need to be an institute member to use the library's full range of services. However, one-day and one-week passes allow you to visit and conduct research, without borrowing privileges.

The library gets busiest from 11 a.m. to 3 p.m. on weekdays and frequently hosts literary events in the evenings, so time your visit accordingly. While you're there, you can check out the building's other treasure: a chess room that the library claims is the oldest in the United States, which hosts everything from casual play to grand-master-level tournaments.

⌲ essentials

57 Post Street, San Francisco, CA 94104

(415) 393-0101

milibrary.org

One-day pass, $12; one-week pass, $45; student membership, $35 per year; individual membership, $95 per year; family membership, $150 per year (see Web site for more information)

Monday–Thursday, 9 a.m.–9 p.m.; Friday, 9 a.m.–6 p.m.; Saturday, 10 a.m.–5 p.m.; Sunday, 1–5 p.m.; closed most holidays

Muni bus: 2, 5, 6, 9, 21, 31, 38, 38L; **Muni Metro:** Montgomery Street Station; **BART:** Montgomery Street Station

peaceful place 59

MILL VALLEY PUBLIC LIBRARY

Mill Valley (MAP EIGHT)

CATEGORY ⌣ reading rooms ⭐ ⭐

*C*ombine the serenity of an alpine lodge with the literary resources of a big-city reading room, and you'll have the Mill Valley Public Library. Dedicated to providing local patrons with a "fantastic place to escape," the MVPL is the perfect hometown getaway for those who live in this pocket town just north of the Golden Gate Bridge. It is equally enticing for other Bay Area residents and visitors sampling the village charms. (If you live anywhere in Marin County, you may apply for a free

A grove of redwoods provides a home for the Mill Valley Public Library.

library card that gives you access to full services here and privileges at all other libraries within the county.)

Located within walking distance of Mill Valley's hilly residential neighborhoods, the handsome concrete-and-glass building is tucked into a grove of parkland redwoods. An open-gable ceiling with dark beams, together with reading lamps, handcrafted chairs, and work tables, creates the feel of an old-school reference room. Winner of an award of excellence from the American Institute of Architects in 1968, the library also features multipaned floor-to-ceiling windows that fill the rooms with light and allow readers to look out on the tranquil forested surroundings. A central fireplace surrounded by gargantuan chairs and an outside deck are reason enough to seek out the place for your reading or reveries.

In the children's room, large stuffed animals await young readers who come armed with their first library cards and the impetus to turn off their Internet games and read. A history room displays books, maps, local artifacts, and other memorabilia about the civic-minded town. A new technology center puts MVPL on the cutting edge, and its iMac computers, loaded with creative applications, are a first for public libraries in Marin County.

⌄ essentials

☰ 375 Throckmorton Avenue, Mill Valley, CA 94941

☎ (415) 389-4292

🌐 millvalleylibrary.org

$ Free library card available to anyone with a California driver's license. (Contact library or see Web site for details on services and checkout privileges offered by this branch and other library locations within Marin County.)

🕐 Monday–Thursday, 10 a.m.–9 p.m.; Friday, noon–6 p.m.; Saturday, 10 a.m.–5 p.m.; Sunday, 1–5 p.m.; closed most holidays

🚌 Golden Gate Transit bus: 4

peaceful place 60

MISSION DISTRICT MURAL ART

Mission District (MAP FOUR)

CATEGORY ⌣ urban surprises ✪

*Y*ou might call the murals a Mission statement. Within the Mission District, hundreds of massive community murals adorn the exterior walls of homes, schools, and businesses, giving color and character to this vibrant neighborhood with deep Latino roots. The district's outdoor galleries sprang from the Chicano Art Mural Movement in the 1970s and draw inspiration from the storytelling frescoes and paintings of such artists as Diego Rivera, explains the Precita Eyes Mural Arts Association. The organization, one of just a few such preservationist groups in the country, is dedicated to conserving and safeguarding this bold and expressive urban art. One way to appreciate the Mission's inner-city painted phenomena is to stroll through the neighborhood's streets, where you'll find large mural concentrations on Balmy and Lilac alleys.

© 2006 Precita Eyes Muralists Association

People Making the World Better Through Their Art *was designed and painted by Precita Eyes Muralists Community Mural Workshop and Urban Youth Arts students.*

You may also take a weekend walking tour offered by a Precita Eyes guide, who will introduce you to skillfully rendered art that illustrates themes such as love of family, pride in the past, political statements, and calls for peace. Recurring images include hearts, radiant suns, bridges, birds, loosened chains, communities of people, and eyes that seem to me to represent the way we view our world. Beautiful color harmonies engage the visual sense, with an emphasis on resonant mixes of red, bright yellow, orange, blue, turquoise, and purple.

If you decide to do a tour, you may be part of a group. However, the groups are often small, so you can enjoy the leader's undivided attention. You can even arrange for a private tour by appointment.

⌣ essentials

⌐≡⌐ Murals concentrated in the central Mission District
Precita Eyes Mural Arts & Visitors Center: 2981 24th Street, San Francisco, CA 94110

ℭ (415) 285-2287

🌏 precitaeyes.org

$ Free; **Precita Eyes tours:** Adults, $8-$15; discounts available for seniors, children, and others; private tours available by appointment

🕐 Open 24/7; **Tours:** Saturday–Sunday, beginning at 1:30 p.m.

🚌 **Muni bus:** 9, 12, 14, 14L, 22, 27, 33, 48, 49, 67; **Muni Metro:** J; **BART:** 16th Street and 24th Street stations

peaceful place 61

MISSION DOLORES

Mission District (MAP FOUR)

CATEGORY ⌣ spiritual enclaves ✪

lfred Hitchcock fans will recognize Mission Dolores (Misión San Francisco de Asís) as the quaint church that had a cameo in *Vertigo*, the suspense master's 1958 film. Madeleine, played by Kim Novak, stands in the church cemetery, communing with her deceased grandmother, while Scottie (James Stewart) observes her from the shadows.

The movie also treats us to an interior view of the quiet chapel, which is San Francisco's oldest building and California's oldest intact mission. The thick-walled adobe church harks back to the city's beginnings under Spanish rule in 1776. An adjacent basilica, constructed later, hosts a thriving parish today and draws throngs to Mass on Sundays and holidays. But during visiting hours, you may explore the old mission more intimately as a sanctum of serenity, as well as a place of historical, cultural, and architectural significance.

Religious icons decorate the chapel's serene garden.

Walk inside the cool chapel to feast your eyes on splendid marvels that have stood the tests of time and restoration. These include the original hand-carved Baroque altarpieces and the unusual chevron-patterned ceiling, which the Ohlone people painted using vegetable dyes in tones of mustard, moss green, and sangria red.

Outside, you'll find the cemetery courtyard, a serene garden dotted with years-old statuary and humble gravestones. Caretakers and docents have begun restoring the ancient grave sites, some of whose original markers were used for firewood in the aftermath of San Francisco's 1906 earthquake. The newly refurbished garden is also lush with new plantings of native flora, including grasses, California poppies, and a California redbud tree, all vegetation that recalls the old mission's earliest days.

↙ essentials

☰ 3321 16th Street, San Francisco, CA 94114

☎ (415) 621-8203

🌐 missiondolores.org

$ **Suggested donation:** Adults, $5; seniors and students, $3

🕐 Daily, May–October, 9 a.m.–4:30 p.m.; November–April, 9 a.m.–4 p.m.;
Good Friday, 9 a.m.–noon; Easter Sunday, 10 a.m.–1 p.m.; closed New Year's Day,
Thanksgiving, and Christmas

🚌 **Muni bus:** 22; **Muni Metro:** J; **BART:** 16th/Mission Street Station

peaceful place 62

MOUNTAIN VIEW CEMETERY

North Oakland (MAP SEVEN)

CATEGORY ↵ spiritual enclaves ✪✪✪

Nestled against the Oakland Hills, Mountain View Cemetery is more than a resting place for famous people and ordinary folk. Designed by renowned landscape architect Frederick Law Olmsted, whose other credits include New York's Central Park and much of Stanford University's grounds, the Victorian-era burial ground reflects the American quest to be in everlasting harmony with nature.

Combining a storied past with spare beauty, the 226-acre rural cemetery is a serene setting that draws locals and visitors alike for walks and reflection. It encompasses a Parisian-style, tree-lined entrance avenue and six gently ascending hills, each marked by verdant lawns and curving lanes. Italian cypresses, Lebanese cedars, and Italian stone pines grow among the native live oaks, lending color and simplicity to the landscape. The lush vegetation forms a serene backdrop to the hundreds of markers, monuments, and mausoleums that dot the hillsides. Many of these architecturally grand edifices provide a sense of the early California and Bay Area spirit. Important figures interred here include banker and railroad magnate Charles Crocker, author Frank Norris, shipbuilder Henry J. Kaiser, and others who helped shape the state's pioneering past.

Just outside the gates stands the Chapel of the Chimes, a funerary structure that's considered one of the Bay Area's most beautiful buildings. Constructed in 1909, the complex was remodeled in 1928 from designs by the legendary Julia Morgan, California's first woman architect. Morgan destroyed all her records, preferring her buildings to speak for her. Clearly, the magnificence of this one does.

⌣ essentials

☰ 5000 Piedmont Avenue, Oakland, CA 94611

☎ (510) 658-2588

🌐 mountainviewcemetery.org

$ Free

🕐 **Grounds:** Daily, 6:30 a.m.–6:30 p.m.; **Office:** Monday–Friday, 8 a.m.–4:30 p.m.;
Saturday–Sunday and holidays, 10 a.m.–4 p.m.

🚌 **AC Transit bus:** 61

peaceful place 63

MOUNT DAVIDSON PARK
West of Twin Peaks (MAP SIX)
CATEGORY ⌄ scenic vistas ✪ ✪ ✪

*I*n San Francisco, every hill is a novel. That was, at least, the declaration of writer William Saroyan, who also waxed eloquent about San Francisco's many geographic charms. Once called Blue Mountain and renamed for its first surveyor, Mount Davidson is the city's highest elevation at 927 feet and has its own story to tell. Declared a city park in 1929, the 38-acre wooded area features the iconic Mount Davidson Cross at its crest. One of the world's tallest crosses and a cherished landmark, it's an enduring symbol of faith and the fourth in a succession of such structures to grace the summit. With the installation of the first one in 1923, the city began a tradition of Easter sunrise prayer services at Mount Davidson that continues today. Although the city no longer owns the cross and the land immediately surrounding it, the park makes for an inspirational destination.

Trails circumnavigate this nature preserve, where fragrant pines and graceful eucalyptus cover the slopes. Along the trailside, you'll see ferns, nasturtiums, wildflowers, and blackberry brambles. Paths and stairways, seemingly to heaven, lead up to the cross, an ascent of less than 1 mile. Along the way, you can take in boundless views of San Francisco and the Bay Area or marvel at the city's cocoon of fog.

⌄ essentials

▤ 125 Dalewood Way, San Francisco 94127 ✆ N/A

❂ sf-recpark.org/index.aspx?page=2413 or bahiker.com/sfhikes/davidson.html

$ Free ⏱ Daily, 6 a.m.–10 p.m.

🚌 **Muni bus:** 36; **Muni Metro:** West Portal Station

peaceful place 64

MRS. DALLOWAY'S

Berkeley (MAP SEVEN)

CATEGORY ⤷ shops & services ✪✪

*T*he bookstore takes its name from *Mrs. Dalloway,* written in 1925 by Virginia Woolf and considered by some to be among the best English-language novels. The book's

opening line, "Mrs. Dalloway said she would buy the flowers herself," provides the inspiration for the Elmwood district shop, where the arts of writing, book-selling, and gardening intersect. The homage to Mrs. Dalloway is complete with the mannequin in the window, a likeness to Woolf's fictional character, who's nicely set up with a good book.

Founded in 2004 by two local residents, each with a métier in editing and publishing, Mrs. Dalloway's has taken hold in this quaint shopping neighborhood just a few blocks south of the University of California, Berkeley campus. In addition to books on horticulture, landscape design, and organic farming, you'll find

This bookstore was inspired by a Virginia Woolf novel.

a well-selected repository of fiction and nonfiction titles, along with books about business, travel, cooking, wine, flower arranging, and home decor.

High ceilings and plenty of natural light create an atmosphere that invites you to browse among each season's fresh crop of books—along with the profusion of classics and other titles. You might be introduced to the Berkeley-based novel *The Cookbook Collector*, by Allegra Goodman, or Laura McCreery's *Living Landscape*, a vivid examination of the nearby East Bay Regional Park District. Settle into one of the red rattan armchairs as you leaf through works by other Bay Area authors, such as novelist Adrienne McDonnell and mystery writer Susan Dunlap.

But if, like Mrs. Dalloway, you prefer to go ahead and buy the flowers yourself, you may want to set the books aside and browse among the delicate vases. Or take note of the small potted succulents and botany-themed note cards for sale. Regardless of your focus, the staff excels not only in creating a calming atmosphere but also at offering speedy, efficient service: the book we ordered arrived in the promised two days' time.

essentials

[≡] 2904 College Avenue, Berkeley, CA 94705

(�C) (510) 704-8222

(🌐) mrsdalloways.com

$ Free; **Book prices:** $2–$250

(🕐) Monday–Wednesday, 10 a.m.–7 p.m.; Thursday–Saturday, 10 a.m.–9 p.m.; Sunday, noon–6 p.m.

🚌 N/A

peaceful place 65

MUIR BEACH OVERLOOK

Mill Valley (MAP EIGHT)

CATEGORY ↙ scenic vistas ✪ ✪ ✪

*W*hen you stand on the Muir Beach Overlook, you're literally at the edge of the continent. This vista point at the tip of a high coastal bluff offers panoramic views of the California coastline and Pacific Ocean, along with vertigo-inducing looks downward, where the land drops hundreds of feet straight into the surf. Peeking out to the south is Muir Beach, a sandy strip on a quiet cove where Redwood Creek reaches the sea. Grab onto the handrail, and follow the sturdy wooden stairway out to the overlook, where brisk air currents swirl around you. Expect an exhilarating experience, but if you have a fear of heights, proceed with caution.

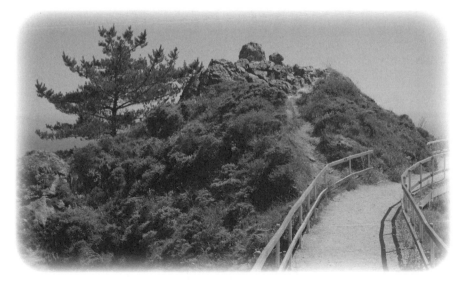

Breathe in the salt-infused air from this dramatic promontory.

The bluff provides a perfect spot for whale lovers to watch these sea creatures swim by during their southward winter—or northward springtime—migrations. Though not as visible to the naked eye, dolphins, porpoises, and seals also populate the Gulf of the Farallones, a sanctuary below that's rich in marine mammals. Along the trail to the overlook, where coastal vegetation and yellow bush lupines grow among squat pines, a plateau features a cluster of picnic tables. It's a dramatic place for a moveable feast, but be prepared to anchor your provisions down against the ocean winds.

essentials

📧	Highway 1, Mill Valley, CA 94965
📞	(415) 388-2596
🌐	parksconservancy.org
$	Free
🕐	Daily, 9 a.m.–9 p.m.
🚌	N/A

peaceful place 66

MUSEUM OF THE AFRICAN DIASPORA
South of Market (MAP TWO)
CATEGORY ✎ museums & galleries ✪ ✪

*C*alled a "first voice" museum, this South of Market cultural institution uses story-telling to capture, explore, and promote the contributions that people of African descent have made internationally. Structured around oratory and musical traditions, the Museum of the African Diaspora shares narratives about the origins of peoples, their scattering and movement throughout the global landscape, and the ways in which they have adapted to, sought fresh prospects in, and transformed their worlds.

Here you won't find the hushed and hallowed halls that you associate with the word *museum*. The minute you walk in, you'll hear music, most of it rollicking enough to set your toes tapping. During one weekday visit, I hung out in the Celebration Circle, where the museum was screening the story of vocalist Celia Cruz, the Cuban-born "queen of salsa." Turning my attention to the interactive environments, I engaged in a bit of child's play by mixing my own music, adding in the sounds of guitars, clave, bass, and calabash gourd. I then checked out a photojournalism exhibition that documented the power of altars, ritual practices, and vocal communication with the supernatural world.

My last stop was the permanent exhibit devoted to culinary traditions, a display tantalizing enough to whet my appetite. By the time I left, the museum had inspired me to regard it as a true gift to the community.

◡ essentials

▣ 685 Mission Street, San Francisco, CA 94105

☎ (415) 358-7200

🌐 moadsf.org

$ Adults, $10; seniors age 65 and up and full-time students with ID, $5; children age 12 and under and members, free; admission to lobby and museum store, free

🕐 Wednesday–Saturday, 11 a.m.–6 p.m.
Heritage Center and Education Center: Wednesday–Saturday, noon–4 p.m.

🚌 **Muni bus:** 5, 6, 9, 9L, 21, 30, 31, 38, 38L, 45, 71, 71L; **Muni Metro:** F, K, L, M, N, T;
BART: Powell Street Station

peaceful place 67

OAKLAND MUSEUM OF CALIFORNIA
Oakland (MAP SEVEN)

CATEGORY ⌣ museums & galleries ✪

*E*ven California's best museums can use a makeover every now and then. Opened in 1969, the Oakland Museum of California (OMCA) is currently receiv-

Gardens thrive at the Oakland Musuem of California.

ing a refurbishment, designed to preserve the original modernist architecture while bringing the downtown venue into the 21st century. Celebrating the art, history, and natural sciences of the Golden State, the museum will continue to undergo its transformation until 2012. But the improved art and history galleries are currently open, as are the delightful outdoor gardens and public spaces.

Visit on a weekday, and take your time exploring OMCA's art collection, which features more than 70,000 works that date back to the 1800s. Perhaps you will be drawn to the early landscape paintings, which depict Yosemite and other natural wonders in a

serene light. You might also study the gallery's strong anthology of Bay Area figurative art, along with sculpture, photography, craft, decorative arts, new media, and documentary materials. Students of California's storied past will want to veer in the direction of the history gallery, where more than 1.7 million objects and artifacts reflect the state's rich and fabled past.

Hailed as a verdant urban park in its early days, the museum still boasts its trilevel terraced gardens, which cover the gallery roofs and take the museum experience outside. The spaces contain more than 85 plant species, including plenty of flowering beauties, more than 50 sculptural works, and a placid water garden filled with koi and lily pads.

↵ essentials

🖃 1000 Oak Street, Oakland, CA 94607

📞 (510) 238-2200

🌐 museumca.org

$ Adults, $12; seniors and students with ID, $9; children ages 9–17, $6; children age 8 and under, free; OMCA members and City of Oakland employees with ID, free; admission free on the first Sunday of every month

🕐 Wednesday, Saturday, and Sunday, 11 a.m.–5 p.m.; Thursday–Friday, 11 a.m–8 p.m.; extended hours on the second Friday of every month until 9 p.m.; closed New Year's Day, Independence Day, Thanksgiving, and Christmas

🚇 **BART:** Lake Merritt Station

peaceful place 68

OCEAN BEACH

Sunset District (MAP SIX)

CATEGORY ⌁ outdoor habitats ✪

*W*ith its 5 miles of sand, mesmerizing wave action, and magnificent sunsets, Ocean Beach offers its own brand of California dreamin'. A destination for surfers who seek thrills and for families out for seaside drives, this stretch of the Pacific Coast isn't exactly off the beaten path. But if you time your visit right (winter, anyone?), you can enjoy pure relaxation.

Let serendipity rule the day. You can easily achieve that without going into the water, where strong waves and cold temperatures can endanger you. How about some contemplative wave watching from the shore, a stroll along the esplanade above the seawall, or a bit of sunbathing on a warmer day? Watch the kite surfers harness the wind with their neon-bright, arc-shaped kites. Study the shorebirds, including the tiny snowy plover, an endangered tideland species. Lose yourself in the beauty of a sunset, sometimes visible on even the foggiest days. Or gather with friends in the mood for tranquility around a nighttime bonfire at one of the fire rings. Stay peaceful; stay ashore.

⌁ essentials

🖃	Great Highway from Point Lobos Avenue to Sloat Boulevard, San Francisco, CA 94121 and 94122
☏	(415) 561-4323 🌐 parksconservancy.org $ Open 24/7
🕐	Free (reservations required for fire-ring use)
🚌	**Muni bus:** 38, 38L (express)

peaceful place 69

O CHAMÉ
Berkeley (MAP SEVEN)
CATEGORY ⌣ quiet tables ✪

*T*he bento box is having its moment, as take-out counters and food trucks cater to diners on the go. O Chamé, the Berkeley restaurant that helped launch the successful fusion of Japanese and California cuisine some years back, offers a lunchtime menu of contemporary riffs on the traditional bento. This congenial spot, with its unhurried service and relaxed ambience, provides a welcome post-shopping retreat on bustling Fourth Street.

Assembled in lacquer trays, O Chamé's lunch boxes will satisfy your cravings for the classic components, including rice, vegetables, and fish. In one dish, roasted Atlantic salmon combines with the flavors of sweet potato and radicchio, burdock root, and spinach with sesame. For vegetarians, the restaurant holds the fish and partners the vegetables with tofu. That's not to say that you can't have something heartier. For comfort food, you might dig into a steaming pottery bowl of soba or udon noodles topped with grilled chicken or roasted squid. Savor some tea, special sake, or wine on the side.

The ticket here is to arrive for an early or late lunch. At the height of the noon-hour service, you might find the sociable crowd a bit noisy for quiet thought or conversation. In fine weather, the shaded front garden offers another alternative. Here a few rustic wooden tables invite you to enjoy a solo meal or some communal time with a couple of friends.

⌣ essentials

▱ 1830 Fourth Street, Berkeley, CA 94710

☏ (510) 841-8783

🌐 themenupage.com/ochame.html

$ **Menu prices:** $13.50–$17.50

🕐 Daily, 11:30 a.m.–3 p.m.; Sunday–Thursday, 5:30–9 p.m.;
 Friday–Saturday, 5:30 p.m.–9:30 p.m.

🚌 **AC Transit bus:** 51B

peaceful place 70

OLD SAINT MARY'S CATHEDRAL NOONTIME CONCERTS

Chinatown (MAP ONE)

CATEGORY ↙ urban surprises ✪ ✪ ✪

*W*hat are you doing for lunch? With this invitation, Old Saint Mary's Cathedral opens its doors to music lovers every Tuesday at midday. With its Noontime Concerts series, the cathedral offers a novel interlude to the workday.

If a Beethoven sonata or Chopin nocturne is your idea of escapism, then the cathedral's year-round program of recitals and music festivals will inspire. Old Saint Mary's has been hosting performances by local and international touring artists since 1988. During one visit, I heard a performance of Chopin's mighty 24 preludes, op. 28, which commemorated the composer's 200th birthday.

What the cathedral lacks in symphony hall acoustics, it makes up for in hospitality and history—not to mention ambience. As California's oldest cathedral, this retreat at the intersection of Chinatown and the Financial District has enough murals, statuary, and richly colored stained glass to add visual interest to your musical experience.

A minimal donation covers the price of concert admission. Share the experience with a small but loyal following of downtown workers, retirees, and students.

↙ essentials

660 California Street, San Francisco, CA 94108 📞 (415) 288-3800

oldsaintmarys.org **$ Suggested donation:** $5 Tuesdays, 12:30–1:15 p.m.

Muni bus: 1, 30, 45; **Muni Metro:** Montgomery Street Station;
Cable car: California Street, Powell/Hyde Street, and Powell/Mason Street

peaceful place 71

OLD ST. HILARY'S

Tiburon (MAP EIGHT)

CATEGORY ⌇ historic sites ✪ ✪ ✪

*T*his iconic landmark church graces a hillside on the Tiburon Peninsula, once part of a sprawling Mexican land grant. Built in 1888 as a place of worship for local railroad workers, Old St. Hilary's has attained architectural significance as one of the few Carpenter Gothic churches to survive in its original setting. You'll see evidence of this wood-hewn rural architecture in the church's pointed arches, steep gables, and jigsaw details.

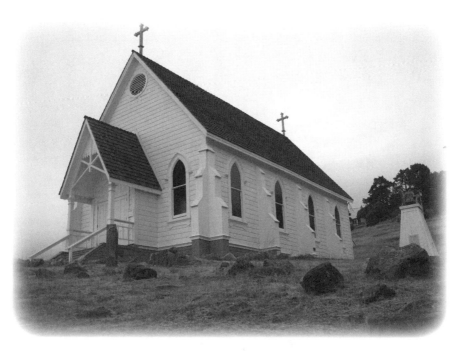

The Carpenter Gothic–style church perches on the Tiburon Peninsula.

The Belvedere–Tiburon Landmarks Society opens the church to the public on Sundays from April through October, giving you a chance to admire the interior. The society informs us that the chapel is constructed of redwood with a fir ceiling and features a restored stained-glass window depicting Saint Hilary, patron saint of scholars. Other appointments include replicas of coal-oil chandeliers, an original white altar, and oak pews that are reproductions of the originals. Conjuring up images of prairie weddings and quilting bees, the church has served in its day as a town hall and a one-room school.

Next to the church is the John Thomas Howell Wildflower Preserve, fields of gold that are home to more than 200 plants that grow in the rush-covered hillsides. Many plants—including the Tiburon paintbrush, which debuts in early spring—are native and some are rare specimens. Summer brings even more indigenous and endangered species, such as Tiburon buckwheat, Marin dwarf flax, and the black jewel flower, which grows only in serpentine, a mineral found on the tip of this peninsula. The church's front doors open onto serene views of bay waters and terraced hillsides.

essentials

☐ 201 Esperanza Street, Tiburon, CA 94920

☏ (415) 435-1853

🌐 landmarks-society.org

$ Free

🕐 April–October, Sunday, 1–4 p.m.

🚗 N/A

peaceful place 72

OMNIVORE BOOKS ON FOOD

Noe Valley (MAP FOUR)

CATEGORY ↙ shops & services ✪ ✪

When it comes to the question of visiting Omnivore Books on Food, there's no dilemma. This petite Noe Valley store is an essential destination for anyone with an appetite for new, antiquarian, or collectible cookbooks. Founded by an avid cookbook collector with a background in rare books, Omnivore is an impressive repository of all things on the "eaten word" (the title of a book I enjoyed years ago).

Browse your way through volumes on topics ranging from urban farming, vegetable gardening, and cooking essentials to secret recipes from underground chefs, decadent chocolate breakfasts, and travels through the world of extreme eating. Vintage books, many with beautiful cloth bindings, gilt lettering, and exquisite illustrations, include first editions from Jacques Pepin, Julia Child, and M. F. K. Fisher and a rare volume of Irma S. Rombauer's *The Joy of Cooking.* You could spend hours poring through the weighty and beautifully illustrated *Ad Hoc at Home* by renowned restaurateur Thomas Keller, who shares his recipes for comfort food. You might want for your culinary bookshelf a copy of Alice Waters's *Edible Schoolyard,* which launched the idea of bringing organic gardening and cooking into school curricula. A volume on practical cookery from Mrs. Beeton, Britain's authoritative culinary author of yore, would amuse or even instruct with its advice about the world of gastronomy before the Cuisinart. Or you could while away a foggy afternoon with a slender tome of sepia photographs and impressive text on San Francisco's bohemian restaurants of yesteryear.

Exuding the ambience of a family kitchen and featuring walls the color of butter, Omnivore Books is a welcoming retreat in this quiet neighborhood, where residences mix with storefronts. The place does heat up when guest authors and chefs come for book signings, often bringing with them samples of dishes created from their new recipes. But

these events have the warm and convivial atmosphere of intimate parties to which you'd love to be invited.

essentials

✉	3885a Cesar Chavez Street, San Francisco, CA 94131
☎	(415) 282-4712
🌐	omnivorebooks.com
$	Free; book prices range from $19 for a new book to $600 for a rare vintage tome
🕐	Monday–Saturday, 11 a.m.–6 p.m.; Sunday, noon–5 p.m.
🚌	**Muni bus:** 24, 36; **Muni Metro:** F, J

peaceful place 73

OSMOSIS DAY SPA SANCTUARY

Freestone (MAP TEN)

CATEGORY ↙ day trips & overnights ❁ ❁ ❁

Climb in and immerse yourself in the warmth. Aided by a cup of organic herbal tea and reflection time in the tea garden, you settle into the Cedar Enzyme Bath, the signature treatment at the Osmosis Day Spa Sanctuary. Your private attendant sculpts a place to support you and covers you up to your chin in the bath, a mixture of light-as-air ground cedar, rice bran, and plant enzymes that heat up naturally through fermentation. The sensation may be a bit unusual at first, but you soon feel gently nurtured as you surrender to the heat and light pressure. For about 20 minutes, you luxuriate, perspire, and let your mind drift. At just the right intervals, your bath attendant reappears with refreshing sips of water and cool cloths for your brow. As you emerge, you feel relaxed, glowing, more agile, and even elated.

Just one hour and 15 minutes from the Golden Gate Bridge, Osmosis waits for you in Freestone, a Wine Country hamlet in Sonoma County, west of Santa Rosa. Reminiscent of a Japanese rural home, the 5-acre sanctuary features simple rustic furnishings and a Zen garden with a melodic waterfall, lily pond, graceful trees, and meditation pagoda. Getting to Osmosis is therapy in itself, as you leave the freeway and wend your way through rich farmland, picturesque homesteads, and green valleys dotted with grazing or resting cows.

While the cedar bath is the touchstone at Osmosis, you may continue on with other services. My attendant ushered me into what she called a resting room, where, cocooned in a blanket, I listened to meditative music intended to deepen relaxation and balance brain wave activity. Next came a 75-minute stress-relieving Swedish massage, the spa's most popular add-on. If you want to make your Wine Country visit an overnight, Osmosis can recommend places to stay and dine, from coastal perches to Russian River nooks and vineyard inns. Your days of play might also include some river kayaking and a tasting of Sonoma's world-class wines.

essentials

☰ 209 Bohemian Highway, Freestone, CA 95472

☏ (707) 823-8231

🌐 osmosis.com

$ Cedar Enzyme Bath for one person, $85; for two or more, $75 each; spa treatments, $110–$295, exclusive of gratuity

🕐 Daily, 9 a.m.–8 p.m.

🚌 N/A

peaceful place 74

OUR LADY OF THE WAYSIDE CHURCH

Portola Valley (MAP NINE)

CATEGORY ⌣ historic sites ✪ ✪ ✪

*S*an Francisco native son Timothy L. Pflueger designed glittering movie palaces, skyscrapers, and cocktail lounges during his relatively brief life (1892–1946). The renowned architect who gave us San Francisco's Castro Theatre and its Stock Exchange building, and the Paramount Theatre in Oakland, began his career with a rural church in the Portola Valley, south of San Francisco. Stop by the wayside to see this humble chapel that served as a precursor to the architect's urbanized designs of the Jazz Age and the Great Depression.

Built in 1912 (yes, Pflueger was only 20), the church was intended for Portola Valley's growing Catholic parish. The design of the stucco church reminds the viewer of Mission Dolores, a historic chapel in San Francisco's Mission District, where Pflueger grew up and spent his adult life. Notable elements at Our Lady of the Wayside include the tiled gable roof, arched windows, and buttressed walls, along with an unusual scrolled pediment above the main doorway. Encircled by a stand of massive redwoods, so old that some have intertwined, the pale-yellow chapel almost radiates a beatific glow.

The church is both a California and national landmark. While not open to the public for drop-in visits, it's part of the Archdiocese of San Francisco and still holds services. A small parking lot allows you to stop by and take a journey back in time.

⌣ essentials

⌷ 930 Portola Road, Portola Valley, CA 94028 ☏ (650) 851-5085

⊕ stdenisparish.org $ Free

⊙ Sunday Mass, 9:30 a.m.; Saturday (vigil), 5:15 p.m.; Tuesday–Thursday, 7:30 a.m.

▱ SamTrans bus: 85

peaceful place 75

PACIFIC AVENUE

Pacific Heights/Presidio Heights (MAP FIVE)

CATEGORY ⌣ enchanting walks ✪ ✪

*M*anhattan may have its Block Beautiful, but San Francisco lays claim to Pacific Avenue. This elegant and famously chic boulevard traverses the city's northwest hills and culminates at the Presidio of San Francisco. As an admirer of historic architecture, I like to take a leisurely stroll along this street of (real estate) dreams and study the Victorian and early-20th-century homes.

Start at the intersection of Pacific Avenue and Octavia Street, and head west. Though modern apartments have replaced many of yesteryear's stately mansions, you'll still see a number of the flat-front Italianates and jigsaw-trimmed Queen Anne homes that are part of San Francisco's DNA.

This manicured and tree-lined enclave becomes even more serene as you progress into tony Presidio Heights, where the traffic dwindles to almost nothing. The grand dwellings reflect a mix of old-world influence—English Tudor, Italian Renaissance, and French Chateau. Also look for fine examples of the Shingle Style, houses named for their exteriors of unpainted shingles and designed by architectural greats Bernard Maybeck (1862–1957), Julia Morgan (1872–1957), and their contemporaries. Your ultimate reward is the magnificent view of the Presidio, with its wind-sculpted trees and shimmering green meadows.

⌣ essentials

📧	2000–3300 blocks, Pacific Avenue, San Francisco, CA 94115 and 94118 📞 N/A
🌐	N/A $ Free 🕐 Open 24/7
🚌	**Muni bus:** 1, 22, 41 (peak hours only), 43, 45

peaceful place 76

PALACE OF FINE ARTS

Marina District (MAP FIVE)

CATEGORY ✄ historic sites ✪ ✪

*T*he parklike setting known as the Palace of Fine Arts casts a moody and other-
worldly spell. Designed by Bay Area architect Bernard Maybeck for the 1915
Panama–Pacific International Exhibition, this mock Greco-Roman monument brings
to mind ancient empires and mythological realms. Its glowing, open rotunda, sculp-
tures of melancholy maidens, and windswept cypress trees beckon tranquility seekers.

These days, this landmark is a favorite retreat of dog walkers, bird-watchers, people
in search of a little untamed nature, and the occasional wedding party. Framed by sky

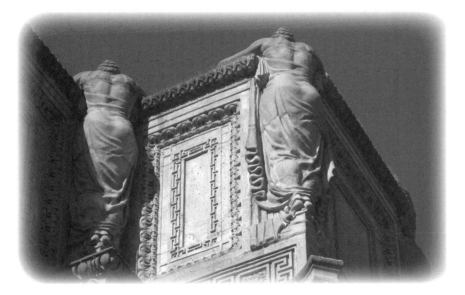

Figures of finely sculpted maidens grace a palace colonnade.

and water, the palace offers one of the city's most pleasing vistas on which to medi-
tate. The octagonal arcade invites you to explore its quiet recesses and commune with
the classical figures engraved on its walls. A placid lagoon—the remains of a primal
slough—ripples out from the monument, forming a reflecting pool. A footpath encircles
the lagoon, allowing you to take a short stroll and get a closer look at the night herons,
migrating ducks, and graceful swans that nest in this habitat.

The grassy slopes around the park's perimeter create the perfect picnicking spot,
when the ground isn't too damp. At night the illuminated rotunda throws shape-shifting
reflections onto the inky lagoon, and you feel as if you want to reach for the stars.

essentials

3301 Lyon Street, San Francisco, CA 94123

(415) 563-6504

palaceoffinearts.org

$ Free

Open 24/7

Muni bus: 30, 30X (peak hours only)

peaceful place 77

PICCINO CAFÉ

Dogpatch (MAP TWO)

CATEGORY ↝ quiet tables ✪✪

*T*ranslated from Italian, *piccino* means "small space," and that sums up the size of this light-filled corner cafe in the Dogpatch district. But, though tiny in square footage, Piccino has a lofty goal: to be as welcoming as the home of a close friend. The restaurant succeeds capably in that aim, making it well worth a visit to little-known Dogpatch, just nine square blocks with a colorful working class past.

In fact, you'll want to become BFF (best friends forever) with Piccino once you've tasted the cafe's thin-crust pizzas, its star attraction. The perfect size for one person—give or take a slice—each pie is assembled with a light hand and topped with simple,

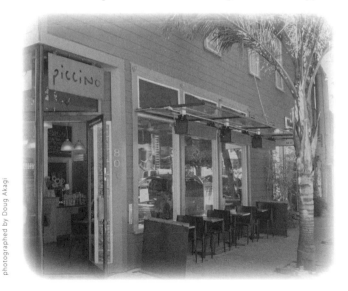

Pizza and a welcoming ambience are star attractions.

photographed by Doug Akagi

locally sourced ingredients. My favorite is laden with roasted exotic mushrooms, garlic, and Crescenza, a moist cow's-milk cheese. A friend leans toward the classic margherita, which marries tomato sauce, dollops of mozzarella, and a pinch of oregano. Round out your meal with antipasti and enjoy a glass of French or Italian wine, and then linger over a bit of dolce and some supremely satisfying Blue Bottle coffee. The cafe's affable service, open kitchen, intimate collection of copper-topped tables, and sidewalk seating complete the home-and-hearth allure.

essentials

✉	801 22nd Street, San Francisco, CA 94107
☎	(415) 824-4224
🌐	piccinocafe.com
$	Pizzas, $10–$16; starters, brunch items, classics, special entrees, and dolce, $5–$18
🕐	**Restaurant:** Tuesday–Friday, 11 a.m.–9:30 p.m.; Saturday–Sunday, 10 a.m.–9:30 p.m.; closed Monday. **Coffee bar:** Monday–Friday, 7 a.m.–5 p.m.; Saturday–Sunday, 8 a.m.–5 p.m.
🚊	**Muni Metro:** T

peaceful place 78

POINT ISABEL REGIONAL SHORELINE

Richmond (MAP SEVEN)

CATEGORY ⌣ outdoor habitats ⭐

*D*ogs have been called the gods of frolic and our links to paradise. If that's the case, you'll be just a little closer to heaven at Point Isabel Regional Shoreline, a wag-worthy and award-winning dog park on the eastern shore of the San Francisco Bay. The nation's largest off-leash dog park, Point Isabel draws 500,000 canines and their best friends per year.

I know. You're imagining "yappy hour," with a cacophony of barking beasts. But woofs and growls keep to a surprising minimum here, where dogs are just too busy exploring and socializing to stir up a ruckus. If you go at less-crowded times, such as late afternoon on weekdays, you're almost guaranteed a yelp-free zone. With 3.2 miles of flat trails, the park features a grassy promontory and the dog-friendly Hoffman Channel, a narrow waterway surrounded by wetlands. Human visitors appreciate the striking views of San Francisco, Marin County, and the Golden Gate Bridge. Peak bird-watching occurs in fall and winter, when migrating fowl join their year-round brethren. The park also offers opportunities for cycling, kite flying, and shoreline angling. And, of course, there are the pettable warm and fuzzy dogs—golden retrievers, whippets, Welsh corgis, miniature schnauzers, and all the wish-we-knew varieties.

The adjacent Mudpuppy's Tub & Scrub offers full-service or do-it-yourself dog baths and blow-drys, along with toys and treats for purchase. Want your own treats? The sister operation, Sit & Stay Cafe, comes to your rescue with espresso drinks and light fare.

⌁ essentials

📧 2701 Isabel Street, Richmond, CA 94803

☎ (888) 327-2757, option 3, ext. 4550; **Mudpuppy's Tub & Scrub:** (510) 559-8899;
Annual permit information (see below): (510) 690-6508

🌐 ebparks.org or mudpuppys.com

$ Free parking; no dog fee for a limited number of dogs. Note that any person who
walks or exercises a dog(s) for a fee or who walks more than three personal dogs
must obtain and have in possession a revocable annual permit (see telephone
number above). **Mudpuppy's dog baths:** $20–$35

🕐 Daily, 5 a.m.–10 p.m., unless otherwise posted or permitted
Mudpuppy's: Monday–Friday, 10 a.m.–5:30 p.m. (last wash at 5 p.m.); Saturday–
Sunday, 8 a.m.–5:30 p.m. (last wash at 5 p.m.)

🚌 **AC Transit bus:** 52L; **BART:** El Cerrito Plaza Station

peaceful place 79

LA PORZIUNCOLA NUOVA
North Beach (MAP ONE)
CATEGORY ↙ spiritual enclaves ✪

*P*erennially overshadowed by neighboring Saints Peter and Paul Church, the National Shrine of Saint Francis of Assisi has come into its own. Built in 1849 and named for the humble saint who preached to the birds, this historic North Beach church became a shrine in 1998. The shrine is also home to La Porziuncola Nuova, a replica —and thus *nuova*, or new—of the original Porziuncola in Italy, where Saint Francis found his calling. The chapel sits within a museumlike space adjacent to the church, which is undergoing a major restoration.

Named a holy place by the pope and blessed by a top Franciscan official, the new Porziuncola features rocks and marble transported from Assisi. It also houses copies of 12 frescoes spanning five centuries and created by Italian masons. The magnificent altarpiece replicates a 1393 masterwork by Ilario da Viterbo, a priest and Italian painter, and depicts scenes from the life of Saint Francis.

Situated on a busy North Beach street corner—where patrons and tables from nearby coffeehouses, bars, trattorias, and gelato shops overflow onto the sidewalks—the cool and quiet Porziuncola beckons visitors to enter. But, because North Beach is a tourist magnet, do so on a quiet weekday morning. You'll have a better chance of enjoying the chapel as its creators intended: as a place to reflect, pray, and feel the presence of the man who gave San Francisco its name.

↙ essentials

📧 624 Vallejo Street, San Francisco, CA 94133 📞 (415) 983-0405

🌐 knightsofsaintfrancis.com **$** Free 🕐 Tuesday–Sunday, 10 a.m.–6 p.m.

🚌 **Muni bus:** 30, 41 (peak hours only), 45; **Muni Metro:** Montgomery Street Station; **BART:** Montgomery Street Station

peaceful place 80

POTRERO BRANCH LIBRARY

Potrero Hill (MAP TWO)

CATEGORY ↙ reading rooms ✪ ✪ ✪

*I*n the 1890s, the San Francisco Public Library established its 22nd branch to serve patrons in the developing Potrero Hill neighborhood. Fast-forward more than 100 years and a few address changes. Today, the Potrero Branch is a sparkling facility with wireless access, a center for teen visitors, and a vastly expanded collection of materials.

The modern structure, designed by San Francisco's Bureau of Architecture, sits on a sunny hilltop, where modest residences mix with corner mom-and-pop stores. The library features a second-level reading area with floor-to-ceiling windows, from which you can see the vibrant cityscape. Spread out before you are such landmarks as the circular skylight that graces the San Francisco Museum of Modern Art, the spire of the Transamerica Pyramid, the carnelian Bank of America Building, the graceful San Francisco/Oakland Bay Bridge, and the very tops of the Golden Gate Bridge towers.

A row of armchairs, whimsically upholstered in a calligraphy-themed pattern, faces the windows, allowing you to enjoy a book, peruse the newspaper, or tap away at a laptop while soaking up the sunlight.

The architects also enhanced the interior with a light touch, adding a central atrium, a play-to-learn wall in the children's area, and more computers. A suspended sculpture by Bay Area artist Gina Telcocci, who uses ancient, traditional, and invented craft techniques to fashion her work, adds to the airy feel of the space.

essentials

☐ 1616 20th Street, San Francisco, CA 94107

☎ (415) 355-2822

🌐 sfpl.org

$ Free

🕐 Tuesday, 10 a.m.–8 p.m.; Wednesday, noon–8 p.m.; Thursday, 10 a.m.–6 p.m.;
Friday–Saturday, 1–6 p.m.; Sunday, 1–5 p.m.; closed Monday

🚌 **Muni bus:** 19

peaceful place 81

PRESIDIO WALL

Pacific Heights (MAP FIVE)

CATEGORY ∿ enchanting walks ✪

*Y*ou begin this urban walk at the corner of Pacific Avenue and Lyon Street—
and it's all downhill from here. The route descends more than 300 feet on Lyon
Street, almost to sea level. Along
the way, wilderness and civiliza-
tion peacefully coexist. One side
of Lyon follows a low stone wall
that keeps the rugged landscape
of the Presidio of San Francisco
at bay. On the other side, the
street skirts three chic neighbor-
hoods as you walk from Pacific
Heights to Cow Hollow and into
the Marina District.

You'll pass pretty private
terraces, meticulously tended
gardens, and a cul-de-sac ringed
with stately homes. Hung Liu's
Migrant Heart sculpture, with its
dramatic paintings of coastal
birdlife, graces the stairway at
midpoint.

As you stroll, breathe in
the scent of eucalyptus in the

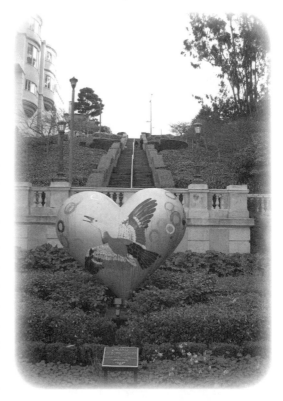

Pause to admire Hung Liu's Migrant Heart *sculpture.*

Presidio, which hosts enough bark, buds, and birds to bring out anyone's inner naturalist. Enjoy a few minutes of discovery as you gaze out over Alcatraz, San Francisco Bay, and the North Bay hills. In the foreground stands the Palace of Fine Arts, a jewel box monument and glorious remnant of the 1915 Panama–Pacific International Exposition.

The Presidio Wall attracts a fair share of exercise enthusiasts, particularly on the weekends. So your best bets are early mornings or weekday afternoons. Occasionally, you'll come across a makeshift lemonade stand, where young entrepreneurs are ready to greet you with a refreshing cooler.

essentials

Lyon Street from Pacific Avenue to Francisco Street, San Francisco, CA 94123

N/A

N/A

Free

Open 24/7

Muni bus: 30, 30X (peak hours only), 41 (peak hours only), 45

peaceful place 82

PULGAS WATER TEMPLE

Woodside (MAP NINE)

CATEGORY ⌣ historic sites ✪✪✪

esigned by San Francisco architect William Merchant, this mock-Roman monument commemorates the completion of the Hetch Hetchy Project, an extensive aqueduct system that delivers water from the Sierra Nevada to San Francisco and other Bay Area cities. Situated in the forested Peninsula Watershed near the aqueduct's terminus at Crystal Springs Reservoir, the graceful Beaux Arts temple was

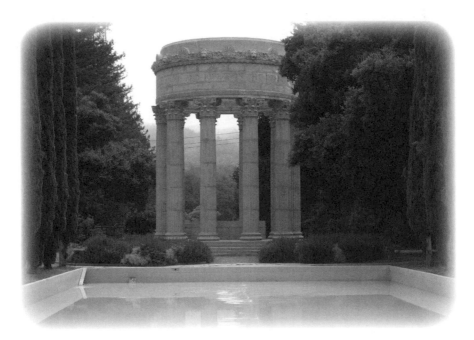

A reflecting pool and cypress trees decorate the grounds of the Pulgas Water Temple.

constructed in 1934. A hidden architectural jewel, the stone masonry shrine consists of fluted columns arranged in a circle and crowned by Corinthian capitals.

The sublime setting also features an east-facing reflecting pool, flanked by an allée of tall, slender cypresses. If you visit on a summer afternoon, you might see fog hanging above the Santa Cruz Mountains that lie to the west of the watershed's grasslands, coniferous forests, and coastal scrub. A fish-and-game refuge, this open space is home to numerous rare and endangered species, including several kinds of butterflies.

In the monument's heyday, water flowed from the mountains to the temple, passing over a small waterfall within the sanctuary before cascading into the reservoir. Though the stream has been diverted since 2004, the temple remains a dreamy ode to a bygone era and a living testament to water as a precious resource.

⌁ essentials

⌑ 56 Cañada Road, Woodside, CA 94062

(✆) **San Francisco Public Utilities Commission** (650) 872-5900

(✪) sfwater.org

$ Free for visits

(☽) Monday–Friday, 9 a.m.–4 p.m.; parking lot closed on weekends, except for permitted events; Cañada Road is closed to vehicle traffic every Sunday, 9 a.m.–3 p.m., November–March, and 9 a.m.–4 p.m., April–October

🚌 N/A

peaceful place 83

REDWOOD ROOM
Union Square (MAP ONE)
CATEGORY ↙ quiet tables ●

he cocktail hour is all about the ambience. And you'll get plenty of that at this cherished landmark bar in the theater district's Clift Hotel. But you'll need to time your visit carefully. Ever since hotelier Ian Schrager and designer Philippe Starck turned the classic Redwood Room into a contemporary wonderland, fans have pushed the boundaries of the velvet rope to get in.

So . . . go before dinner on a weeknight, as friends and I do, when you can sink into one of the stylish chairs for some warm conversation and a cool martini in the Living Room off the lobby. Soft lighting, monochromatic furnishings, and intimate seating arrangements maintain the swanky feel that has made this elegant lounge a destination for decades. The namesake redwood paneling in the spacious bar happily survived the renovation. It gives some mid-20th-century grounding to the modern and dreamlike interiors.

↙ essentials

⌷ 495 Geary Street, San Francisco, CA 94102

☏ (415) 929-2372

🌐 clifthotel.com

$ Cocktail prices: $9–$25

🕐 Sunday–Thursday, 5 p.m.–2 a.m.; Friday–Saturday, 4 p.m.–2 a.m.

🚌 **Muni bus:** 38; **Muni Metro:** Powell Street Station; **BART:** Powell Street Station

peaceful place 84

REGIONAL PARKS BOTANIC GARDEN

Berkeley (MAP SEVEN)

CATEGORY ⌇ parks & gardens ✪

*J*f you've ever walked a California trail and been stumped in identifying even the most common wildflower, help is near. The Regional Parks Botanic Garden, located in Tilden Regional Park, hosts thousands of native California trees, shrubs, grasses, and flowers. Visit this magical space, and it won't be long before you know your western columbines from your woolly blue curls.

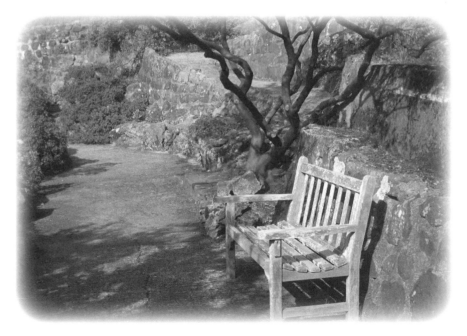

You'll find a place for quiet meditation in the botanic garden.

The botanic garden lies up in Wildcat Canyon, a woodsy crevasse in the north Berkeley hills. Getting there is half the fun, as you wind your way into the canyon and admire jaw-dropping views of the Bay Area at every turn.

Dedicated to the collection, growth, display, and conservation of native plants and their habitats, the 10-acre landscape serves as a living outdoor museum. Whether you're an experienced botanist or an eager amateur, you'll delight in strolling among the landscape's 14 floral areas, which replicate everything from Sierran meadows to Pacific rain forests to hard-tack deserts.

This sanctuary is also simply a delightful place to get lost on a Friday afternoon. Enjoy the calming effects of sunshine, birdsong, the garden's burbling brook, and free parking. The landscape is at its floral best in spring and summer. An autumn tour, however, will banish any complaint that California doesn't have a true fall season. Avoid the Thursday-morning plant sales and the annual mega-sale on the third Saturday in April, when nature and commerce don't mix.

⌣ essentials

[≡·] Wildcat Canyon Road and South Park Drive, Berkeley, CA 94708

(𝐂) (510) 544-3169

(📍) ebparks.org (look for "Tilden Regional Park")

$ Free

(🕐) **October–May:** 8:30 a.m.–5 p.m.; **June–September:** 8:30 a.m.–5:30 p.m.; closed New Year's Day, Thanksgiving, and Christmas

🚌 **AC Transit bus:** 67 (Saturday–Sunday and holidays from Berkeley BART station; Monday–Friday, limited service)

peaceful place 85

RICHARDSON BAY AUDUBON CENTER & SANCTUARY

Tiburon (MAP EIGHT)

CATEGORY ⚐ outdoor habitats ✪ ✪

*T*wo kinds of visitors come to this small preserve on the Tiburon Peninsula—wildlife and people. Most days, there's plenty of the former and very little of the latter. This haven for plants and animals occupies an 11-acre land base and an adjoining 900 acres of bay water, much of it protected by the National Audubon Society. Despite the sanctuary's urban periphery, abundant wildlife dwells here. So get out your binoculars, lace up your hiking shoes, and set out on the looping half-mile trail.

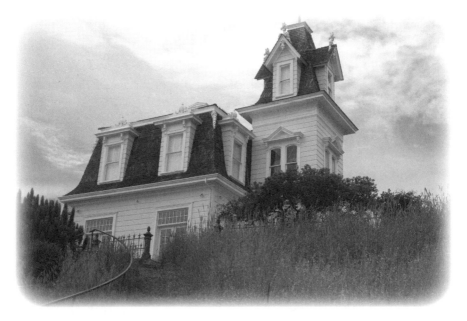

The historical Lyford House overlooks Richardson Bay.

Your self-guided walk will take you past tidal mudflats, coastal salt marshes, old orchards, open grasslands, and the one vestige of civilization—the pastel yellow Victorian-era Lyford House, which is now a small museum. Watch snowy egrets forage in shallow waters, ducks dive deep for shellfish, and tiny invertebrates hide in the mudflats. Listen to migratory warblers, and in spring witness the explosion of lupines, Indian paintbrushes, and other dazzling wildflowers.

While the sanctuary is a place for small discoveries, you'll make grand ones as well. Find inspiration in the restful view of fog-shrouded Mount Tamalpais or the panorama of San Francisco, which looks like an Impressionist's composition in the distance. Calm and collected from the sanctuary, you may want to consider the neighboring site of local nostalgia, Blackie's Pasture. Formally known as the Leo J. Tugenberg Playground, this recreational area is nicknamed for a swaybacked working horse who made history in 1938 by swimming across the San Francisco Bay. Retired to the pasture, Blackie became a local mascot and is immortalized in a life-size sculpture that likely had the meadow nearly to itself at one time. Now the eternal Blackie is encroached upon by a busy Tiburon Boulevard intersection and the proximity of cyclists, baby strollers, soccer fields, and the playground. But as you pause or pass by, you can send a peaceful thought Blackie's way, for old time's sake.

⌣ essentials

[≡ˉ] 376 Greenwood Beach Road, Tiburon, CA 94920 (adjacent Blackie's Pasture at Tiburon Boulevard and Pine Terrace)

(𝐂) **Sanctuary** (415) 388-2524 (☏) tiburonaudubon.org $ Free

(🕐) Monday–Saturday, 9 a.m.–5 p.m.; Lyford House hosts open houses on certain Saturday afternoons, 1–4 p.m., May–October (check the Web site above for specific days)

(🚌) Golden Gate Transit bus: 19

peaceful place 86

RIDGE VINEYARDS/MONTE BELLO

Cupertino (MAP TEN)

CATEGORY ⌄ day trips & overnights ✪ ✪

ometimes a winery is as much about the location as it is about the wines. Ridge Vineyards, built into a mountainside that overlooks the Santa Clara Valley, makes for a lovely place to enjoy some tastings and bask in spectacular views with a friend or two. Nearly 4.5 miles of scenic hairpin turns take you up to this 2,300-foot aerie in the Santa Cruz Mountains, just 32 miles from San Francisco.

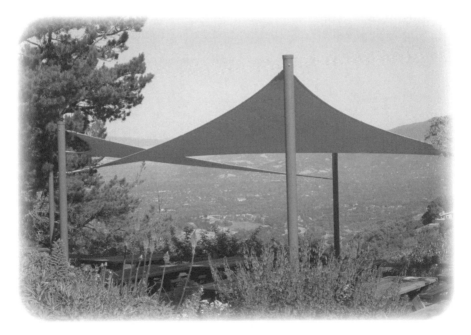

Torch lilies and a vista of Santa Clara Valley enhance a canopied picnic area.

Set aside a weekend afternoon of downtime for a picnic and a visit to the redwood-hewn winery, where the professional staff will pour you a flight of Ridge selections, including the cabernet and zinfandel bottlings for which the estate is best known. When you're ready to tuck into your moveable feast, purchase a bottle of the vintner's finest, uncork, and head out to one of the picnic tables on the mountaintop promontory.

Situated under a taut canopy that provides a generous dappling of shade, the casual outdoor dining area is bordered by red-and-yellow torch lilies and other bright blossoms. From here, you can take time to admire the varied topography that stretches beyond the ridgeline in this cool microclimate, including forested mountains, bay marshlands, stark peaks, and the communities that together are known as Silicon Valley.

Tasting note: The winery, which celebrated its 50th anniversary in 2010, owes its elevated status to more than geography. Ridge Monte Bello ranked fifth among French and California wines at the famous 1976 wine competition that came to be known as the Judgment of Paris. At the judgment's 30th-anniversary reenactment, the estate's cabernet placed first in both the original-vintage and new-vintage categories.

↵ essentials

✉	17100 Monte Bello Road, Cupertino, CA 95014
☎	(408) 867-3233 🌐 ridgewine.com
$	Guest & Member Tasting, $5; Monte Bello Tasting, $20; use of picnic tables free to customers, with appointments required for parties of eight or more; wines, $20–$135 and up
🕐	Open for tastings and sales Saturday–Sunday, 11 a.m.–5 p.m. (April–October), 11 a.m.–4 p.m. (November–March); picnic tables available on first-come, first-serve basis (I recommend visiting during off-peak hours to ensure a table). You may make an appointment for a tasting, which improves your chances of securing a table. Appointments are required for parties of eight or more people.
🚇	N/A

peaceful place 87

RING MOUNTAIN OPEN SPACE PRESERVE

Corte Madera (MAP EIGHT)

CATEGORY ⌇ scenic vistas ✪ ✪ ✪

*R*are wildflowers and prehistoric artifacts have helped stave off development on this small preserve in Marin County. The Tiburon mariposa lily, found nowhere else in the world, and a rock with Coast Miwok petroglyphs are its claims to fame. But the outback boasts many other glories, including quiet hiking trails and, for those in search of scenery, sweeping views of Mount Tamalpais and south to San Francisco.

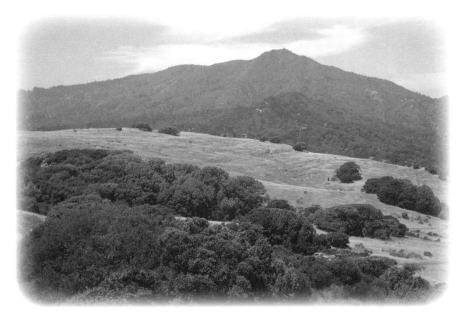

Mount Tamalpais forms a majestic backdrop to the open woodlands.

An unobtrusive gate on Paradise Drive signals that you've arrived. Several trailways lead through the preserve's lower elevations, into open woodlands and up to the Ring Mountain summit. You might feel a bit like a mountain goat as you proceed steadily up the hill's clay paths, pausing to admire the wildflowers, including the famed cream-colored lilies, lavender Ithuriel's spears, and minuscule coral blossoms. Near the ridge stands a weathered boulder with the Miwok carvings. You'll also see large oak-shaded outcrops of serpentine, a mineral that creates special growing conditions for several rare plants that flourish here.

From the summit, you can look out over Tiburon, Belvedere, San Francisco, and expansive bay waters. The full span of the Richmond–San Rafael Bridge unfolds before you, a marvel of engineering that often takes a backseat to the Bay Area's two more famous bridges.

essentials

▭ Paradise Drive, Corte Madera, CA 94925

✆ **Marin County Department of Parks and Open Space** (415) 507-2816

🌐 marinopenspace.org

$ Free

🕐 Daily, sunrise–sunset

🚌 N/A

peaceful place 88

RODEO LAGOON LOOP

Marin Headlands (MAP EIGHT)

CATEGORY ⚹ outdoor habitats ✪

*F*or a short hike outside the city, look no farther than this minimal-effort trek around Rodeo Lagoon in the starkly beautiful Marin Headlands, just north of the Golden Gate Bridge. The surrounding valley, with its namesake lagoon, is the starting point for all things outdoorsy in the region, which lies in a national park.

A quiet trail meanders around Rodeo Lagoon.

The 1.5-mile dirt trail circles the lagoon, descending midway onto Rodeo Beach, an expanse of pebbles and dark sand on the Pacific Ocean. It takes about one hour to hike the relatively flat route, making it the perfect starter hike for young children. Begin at the Marin Headlands Visitor Center, a former military chapel, and follow the trailhead signs. Leashed dogs are allowed, but make sure you observe the center's tips for exploring with your canine companion. Take along some picnic fixings, which you can enjoy at tables on the lagoon's north side.

Rodeo Lagoon Loop has become increasingly popular for spring and fall excursions. So, aim for a morning hike, when fewer trekkers will impede your path. Wildflowers overtake the hillsides and water's edge in spring, when the path is strewn with endless buttercups, seaside daisies, cow parsnips, and lupines. If you're a birder, add binoculars to your backpack. The area supports more than 250 birds, among them the endangered brown pelican, which roosts and splash-dives in Rodeo Lagoon from spring to autumn. During the fall, you can catch sight of migrating raptors, including eagles, hawks, and falcons, as they circle the skies above the promontories to gain some thermal lift before heading south.

⌣ essentials

▣	**Marin Headlands Visitor Center:** 948 Fort Barry, Sausalito, CA 94965
ℭ	Visitor center (415) 331-1540
⊕	nps.gov/goga/planyourvisit/focr.htm
$	Free
⊙	**Parklands:** Daily, sunrise–sunset
🚌	**Muni bus:** 76 (Sundays and holidays only)

peaceful place 89

SAMOVAR TEA LOUNGE

Castro District (MAP FOUR)

CATEGORY ⌣ quiet tables ✪

*P*ractice peace. Drink tea. That's the message from Samovar Tea Lounge, where the soothing properties of hot tea are celebrated and you're encouraged to slow down and find some inner serenity, as the restaurant's owner says, sip by sip. Like an Eastern caravansary on a well-traveled route, this sanctuary of calm beckons you in from the bustling streets of the Castro neighborhood. Tall windows emit generous sunlight, illuminating the bright red walls and the Buddha figures that decorate the small cafe. The knowledgeable staff is attuned to your mood and can recommend the right brew to induce calm and restore your vitality. The music playlist alone, featuring a rhythmic fusion of African, Latin American, Caribbean, and Middle Eastern sounds, will invite you to linger.

Partake from a menu of seasonally harvested and handcrafted artisanal teas and herbal mélanges. Choose from the more familiar Earl Grey and a malty breakfast blend or go for Fujianese white tea, antioxidant-rich Yerba Mate, or hand-whisked Matcha. Start out tame with an English Breakfast tea service, with strong black tea accompanied by small platters of quiche, scones, and fresh fruit. Or travel to more adventurous territory with the Middle Eastern–inspired Moorish platter, accompanied by mint tea, or the Japanese Maki bowl, with its fortification of a brown-rice brew. Sandwich, salad, dessert, and brunch offerings also have a pan-Asian bent. *Hint:* Don't miss the intensely flavored Fudge-Matcha Brownie with Green Tea Mousse.

For the quietest experience, try a midweek brunch or lunch. Warm up, inhale the aromatic essence of leaf and spice, taste the earthy elixir, and go on your way fully revived.

↙ essentials

☰ 498 Sanchez Street, San Francisco, CA 94114

☎ (415) 626-4700

🌐 samovarlife.com

$ Prices range from $7 for brunch items, sandwiches, and salads to $19 for tea service; prices for desserts range $5–$40 (the latter includes tea service for four)

🕐 Daily, 10 a.m.–10 p.m.

🚌 **Muni bus:** 33; **Muni Metro:** F, K, L, M; **BART:** 16th/Mission Street Station

peaceful place 90

SAN FRANCISCO ART INSTITUTE

Russian Hill (MAP ONE)

CATEGORY ✎ scenic vistas ✪

*Y*ou don't have to be a student at this prestigious school of contemporary art to enjoy its cloistered campus or panoramic view. With a medieval tower, red-tiled roof, and central courtyard, the building has the feel of an early California mission. The institute encourages visitors to drop by, check out its art-covered walls, and sample the cuisine at the Café at SFAI.

Weekends, when just a few students are hanging out, make the best times to come for the art and the view. However, the Café at SFAI deserves your attention, and it is open only on weekdays. This cafe is truly a best-kept secret for its organic, local, and seasonal breakfast and lunch fare, which includes pastries, eggs, hot cereal, soups, salads, sandwiches, and light entrees.

Perched atop the school's north side, the cafe, surrounding

An inspiring vista unfolds from atop the art institute.

piazza, and outdoor seating areas offer photo ops galore—including vistas of Alcatraz, Treasure Island, and the angular shapes of San Francisco's skyline.

Just off the courtyard, the Diego Rivera Gallery features *The Making of a Fresco Showing the Building of a City,* one of several murals the acclaimed Mexican artist painted in San Francisco. Look for the unmistakable presence of Rivera himself in the fresco, with his back to the viewer. If you do visit on weekends, you might have this gallery all to yourself.

For all its monastery-like seclusion, the school has a reputation for attracting heavy hitters in the fine, applied, and performance arts. Luminaries who have graced the halls include artists Mark Rothko and Elmer Bischoff, author and activist Angela Davis, photographer Annie Leibovitz, and alumna Kathryn Bigelow, the first woman to win a best-director Oscar.

essentials

800 Chestnut Street, San Francisco, CA 94133

(415) 771-7020; **Cafe** (415) 749-4567

sfai.edu

Free; **Cafe prices:** $4–$6

Campus: 8:30 a.m.–sunset. **Cafe:** spring/fall semesters, Monday–Friday, 8:30 a.m.–3 p.m.; summer session, Monday–Friday, 9 a.m.–2 p.m. Hours vary, so call to confirm.

Muni bus: 30; **Cable car:** Powell/Mason Street

peaceful place 91

SAN FRANCISCO INTERNATIONAL AIRPORT PUBLIC ART

San Mateo County (MAP NINE)

CATEGORY ✌ urban surprises ⭐

*A*s airports go, San Francisco International, or SFO by its routing code, offers some soothing attractions to help keep your spirits aloft. Guaranteed to take the edge off your security-checkpoint experience, the airport's public-art exhibitions feature more than 75 permanent works by noted local, national, and international artists. As you walk through the lobbies and gate rooms, you'll see an impressive array of paintings, sculptures, murals, and environmental works.

Some works are featured in pre-security areas, so you don't need to be a ticketed traveler to enjoy them. The International Terminal showcases an additional 17 pieces, such as James Carpenter's *Four Sculptural Light Reflectors*, visible on the ceiling, or Ann Preston's *You Were in Heaven*, a domed work that suggests sky and clouds.

History buffs can check out the Aviation Library and Louis A. Turpen Aviation Museum, also housed in the International Terminal. A replica of San Francisco's original 1937 terminus, the museum offers a restful spot to unwind. For more "art on the fly," simply bounce along on the people movers and view the exhibitions of pottery, curio collections, and other ephemera as you float by.

⌣ essentials

▤ Highway 101, San Francisco, CA 94128

☏ **Airport** (800) 435-9736 or (650) 821-8211
San Francisco Arts Commission (415) 252-2590

🌐 flysfo.com or sfartscommission.org

$ Free; some access restricted to ticketed travelers only

🕓 Open 24/7; **Aviation Library and Louis A. Turpen Museum:** Sunday–Friday, 10 a.m.–4:30 p.m.

🚌 **SamTrans bus:** KX, 292, 397 (night owl); **BART:** lines vary, depending on day and time of travel; **Caltrain:** Millbrae Station, with a BART connection to airport

peaceful place 92

SAN FRANCISCO MUNICIPAL RAILWAY LINE 76/MARIN HEADLANDS

Sausalito (MAP EIGHT)

CATEGORY ⌣: urban surprises ⭐

*I*f you're bound for the Marin Headlands, why not go green and take a Muni bus? While the city's public transportation coaches have logged a lot of miles and offer few amenities, they have a leave-the-driving-to-us advantage, the benefit of reduced carbon emissions, and a special charm when they're headed to destinations like this.

On Sundays and holidays, Muni, which is short for the San Francisco Municipal Railway, operates the surprisingly crowd-free and round-trip 76 bus line. The coach starts at the Fourth and Townsend train depot and lumbers its way north through town, bypassing colorful neighborhoods and business districts. About 20 minutes later, it reaches the Golden Gate's toll plaza and makes the crossing, affording you stellar views of sailboats on the bay and some refreshing Pacific Ocean air-conditioning.

North of the bridge, when you reach the majestic geological formation known as the Headlands, stay on the bus. You can enjoy a relaxing drive-by of defunct military installations, among them forts, batteries, bunkers, and a missile site. (Or jump off the coach at various stops to visit hiking trails, the Point Bonita Lighthouse, an arts enclave, pristine Rodeo Beach, and a center dedicated to the rescue and rehabilitation of distressed marine mammals.) Wander out to the headland promontories to behold unmatched vistas of San Francisco and the bridge, with its orange towers poking through the fog.

But you're not done yet. For the return trip, just sit back and doze, knowing that Muni is picking up the tollbooth tab.

essentials

☰ᐧ Marin Headlands Visitor Center: 948 Fort Barry, Sausalito, CA 94965

☎ Visitor center (415) 331-1540

🌐 sfmta.com or nps.gov/goga/marin-headlands.htm

$ Bus fare: Adults, $2; passes, discounts, and transfers available (see sfmta.com)

🕐 Parklands: Daily, sunrise–sunset

🚌 Muni bus: 76 (Sundays and holidays only; check Web sites sfmta.com or 511.org for scheduled times and stops in Marin Headlands)

peaceful place 93

SAN FRANCISCO MUSEUM OF MODERN ART ROOFTOP GARDEN

South of Market (MAP TWO)

CATEGORY ❧ urban surprises ✪

"*A* gallery without a ceiling." That's how Mark Jensen, the architect of the San Francisco Museum of Modern Art rooftop garden, describes his addition of this sky-high oasis to Mario Buatta's iconic building. Designed as a new space for showcasing sculptural works, the garden features two open-air plazas and an indoor glass pavilion.

Located on the fifth floor, the garden can be your hideaway on weekday afternoons, except on free-admission Tuesdays once a month and on Wednesdays, when the museum is closed. During the week, you'll share the space with just a few other museumgoers and take in the art installation, as well as the surrounding San Francisco skyline, without all the hustle. The inaugural collection of works featured pieces by big-name artists such as Robert Arneson, Barnett Newman, and Alexander Calder.

The space includes a coffee bar, where baristas serve up excellent espresso, pastries, and sandwiches, which you can enjoy at seating areas interspersed among the sculptures. Elegant glass windows and a lava stone wall create a sense of seclusion and a windbreak. But all is not painted aluminum or weathering steel in this garden on high. Large minimalist containers of plants and deciduous patio trees serve as interesting counterpoints to the abstract and figurative pieces of art.

⌣ essentials

▭ 151 Third Street, San Francisco, CA 94103

☎ (415) 357-4000

🌐 sfmoma.org

$ Adults, $18; seniors age 62 years and up and students, $9; children age 12 and under (accompanied by an adult), museum members, and active U.S. military members with ID, free; admission free on the first Tuesday of every month; half-price admission Thursday, 6–8:45 p.m.

🕐 Thursday, 11 a.m.–8:45 p.m.; Friday–Tuesday, 11 a.m.–5:45 p.m.; closed Wednesday; opens at 10 a.m. from Memorial Day to Labor Day; closed New Year's Day, Thanksgiving, and Christmas

🚍 **Muni bus:** 5, 9, 14, 30, 38, 45; **Muni Metro:** Montgomery Street Station; **BART:** Montgomery Street Station

peaceful place 94

SAN FRANCISCO THEOLOGICAL SEMINARY

San Anselmo (MAP EIGHT)

CATEGORY ∿ spiritual enclaves ✪

*J*t's as if someone waved a magic wand over the Marin County hills and created this mystical, out-of-the-way place. A San Anselmo institution since 1892, the San Francisco Theological Seminary devotes itself to graduate theological education in one of the most divine academic settings in Northern California.

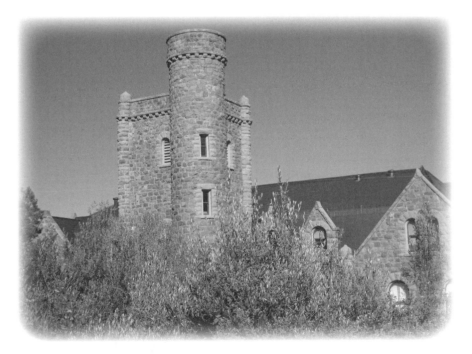

You can't overlook the stone "castle" at the San Francisco Theological Seminary.

Reminiscent of castles in the air, the seminary's turreted stone buildings rise up from pine-covered Seminary Hill in the center of the property. The surrounding grounds, which were designed by noted horticulturist John McLaren—friend to John Muir and a developer of Golden Gate Park—seem a bit carved up now, with more commonplace buildings dotting the landscape. But Seminary Hill, which overlooks redwood-studded Ross Valley and the north side of Mount Tamalpais, rermains a place where urban life fades away and a bit of enchantment takes over. Geneva Terrace features outdoor benches from which to enjoy the vista, the scent of pine, some birdsong, and a seven-circuit labyrinth for walking in meditation and prayer.

Follow the circular road to the summit of Seminary Hill and the main enclave of historic buildings. The seminary is the site of frequent student events and wedding ceremonies, but Friday afternoons seem a particularly quiet time to visit.

essentials

✉	105 Seminary Road, San Anselmo, CA 94960
☏	(800) 447-8820, ext. 831
🌐	sfts.edu
$	Free
🕐	Open 24/7
🚌	**Golden Gate Transit bus:** 22, 24 (peak hours only)

peaceful place 95

SAN FRANCISCO ZEN CENTER

Western Addition (MAP THREE)

CATEGORY ↙ spiritual enclaves ✪ ✪ ✪

Located in what's now called Zen Valley, the San Francisco Zen Center is one of the largest Buddhist sanghas, or communities, outside Asia. Situated on a quiet residential street lined with ornamented Victorian houses, many designed by prominent 19th-century architects, the center occupies a formal redbrick building by renowned architect Julia Morgan. A second-story loggia graces the building, its arched windows reflecting the bright magenta bougainvillea that blooms in the neighborhood during early summer.

Established in 1962, the center has been part of San Francisco's spiritual character and identity for decades. Guided by the words of Zen master and founder Shunryu Suzuki Roshi (1904–1971)— "warm hand and heart to warm hand and heart"—the sangha embraces the belief that all beings are Buddha and that meditation is the pathway to enlightenment.

Here you can expect to find a cross section of people who appreciate Zen philosophy: from priests and monks to students, visitors, and laypersons. Both a meditation and gathering place, the center offers monastic retreats, classes, lectures, residential student programs, and opportunities to discuss your spiritual side with an experienced practice leader.

A small bookstore, composed of several incense-imbued rooms, features works on spirituality, philosophy, poetry, health, and eating well. You'll also find good reads for children, along with Buddha figures, garden statues, and meditation benches and cushions.

essentials

✉	300 Page Street, San Francisco, CA 94102
☎	(415) 863-3136
🌐	sfzc.org
$	Fees for workshops, retreats, art shows, and other events range $10–$150. Some events are priced on a sliding scale, and discounts are available for San Francisco Zen Center members and for individuals with limited incomes.
🕐	**Office:** Monday–Friday, 9:30 a.m.–12:30 p.m. and 1:30–5 p.m.; Saturday, 8:30 a.m.–noon; hours vary during retreat times
🚌	**Muni bus:** 6, 47, 49, 71, 71L, 90; **Muni Metro:** F, J, K, L, N, S, T

peaceful place 96

SATHER TOWER (THE CAMPANILE)

Berkeley (MAP SEVEN)

CATEGORY ✔ scenic vistas ✪ ✪

he University of California, Berkeley fires a 750-pound cannon whenever its Golden Bears football team scores or wins a game. But a far more melodious sound fills the bucolic campus three times a day (four on Sundays) when the university's carillonneurs play brief bell concerts from the top of Sather Tower. Standing at the heart of the campus, the tower rises 307 feet and is the school's most celebrated visual symbol. More commonly known as the Campanile, it's also the world's third-tallest bell-and-clock tower.

While the concerts form a familiar part of campus life, students and visitors are also drawn to the building's observation deck, located at the 200-foot mark. A narrow elevator, operated by an attendant, takes you up to the open-air deck. From here, you can enjoy 360-degree views of the university grounds. This is no small vista, as the panorama covers some 1,232 acres that host a 178-acre sylvan core of conifers, oaks, eucalyptus, and magnolias. Beyond the campus, views open up to the surrounding cities, hills, and the San Francisco Bay. From up here, a lone spire of the Golden Gate Bridge rises like a ship's mast. Cool bay air drifts through the Gothic Revival–style tower, and bells loudly toll the hour from morning to late evening.

Designed by prominent architect John Galen Howard and listed on the National Register of Historic Places, the site features a tree-lined esplanade at its base, the best place from which to hear a resounding 61-bell carillon concert. Despite the resonance, the tower is known as a spot for meditation and solace.

essentials

 University of California, Berkeley, CA 94720; **Visitor Services:** 101 Sproul Hall, Telegraph Avenue and Bancroft Way. (No single official address exists for the university, but for GPS navigation systems, use 2501 Bancroft Way, Berkeley, CA 92704.)

 (510) 642-5215

visitors.berkeley.edu

$ Adults, $2; seniors, California Alumni Association members with ID, and children ages 3–17 , $1; children age 2 and under and UC Berkeley students, faculty, and staff with ID, free

Monday–Friday, 10 a.m.–3:45 p.m.; Saturday, 10 a.m.–4:45 p.m.; Sunday, 10 a.m.–1:30 p.m. and 3–4:45 p.m.; **Visitor Services:** Monday–Friday, 8:30 a.m.–4:30 p.m. (On Saturday and Sunday, Visitor Services staff are available at the tower to answer questions.)

AC Transit bus: 1, 7, 51, 52; **BART:** Downtown Berkeley Station; **UC Berkeley Campus Shuttle** (Monday–Friday): bus service from Downtown Berkeley near BART station to campus perimeter, Botanical Gardens, and Lawrence Hall of Science

peaceful place 97

SENSPA

Presidio (MAP FIVE)

CATEGORY ✴ shops & services ✪ ✪ ✪

With its colorful military past and hip new beginnings, the Presidio of San Francisco walks a fine line between the old and the reincarnated. The 1,500-acre expanse on the city's coastal bluffs is now a historic preservation project and a stunning national park. It's also home to a carefully planned mix of A-list tenants, including SenSpa. In keeping with the Army aesthetic, the spa offers its services in a weather-beaten former medical warehouse that belies the soothing vibe waiting within.

Treatments here will make you forgo the park's hiking trails and seek an entirely different path to well-being. Or perhaps you will come here after a good, long trek to reward yourself with a Tibetan foot ritual, a cucumber facial, a body peel, or a gentle massage designed to chase away your sore muscles.

My own spa day included a stress-dissolving massage. Aromatic oils, down-tempo music, and my masseuse's skilled hands coaxed me into deep relaxation. I also chose a skin-brightening facial, entrusting my fine lines to an aesthetician who swirled my face with gentle brushes and applied a cocktail of purifying papaya.

The warming room welcomes you for post-treatment cocooning and nap time. You may also linger in the interior garden, where a skylight admits views of the fog floating overhead. Don't forget quenchers of ice water to slake your thirst and a good steam in the sauna. Ahhh, don't you feel better?

essentials

 1161 Gorgas Avenue, San Francisco, CA 94129

 (415) 441-1777

senspa.com

$ Prices range from $70 for a 30-minute express massage to $825 for a three-and-a-half-hour facial suite

Monday, by reservation only; Tuesday–Friday, 10 a.m.–9 p.m.; Saturday–Sunday, 9 a.m.–7 p.m.

Muni bus: 30

peaceful place 98

SIGMUND STERN GROVE

Sunset District (MAP SIX)

CATEGORY ᨑ parks & gardens ✪ ✪

ometimes called "nature's music box," Sigmund Stern Grove is a natural amphitheater whose magical acoustic qualities come from the tall, fragrant eucalyptus

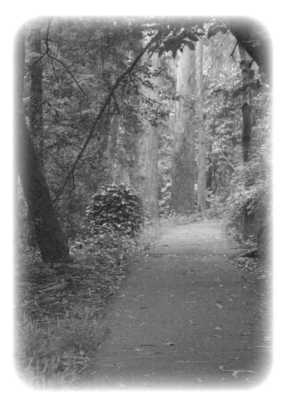

A captivating path winds through eucalyptus trees.

trees that cover the ground's slopes. Locally called Stern Grove, the city park encompasses acres of former farming and cattle lands, and for more than 70 years, it has been the concert setting for the annual Stern Grove Festival, a summer season of free events.

Donated to the city by Mrs. Sigmund Stern in memory of her husband, the grove is more than just a concert meadow where sonatas soar. Overall attendance at the performances can number in the hundreds of thousands, so you'll want to find other times and ways to enjoy this lush environment. A peaceful retreat for harried city residents since its early days, when

the Sunset District was called the "outerlands," the park remains a wonderful retreat on a day when you have no particular place to go. Take a stroll on one of the pathways and inhale the scent of pungent eucalyptus. Let Fido out for a walk and exhilarate in the magic of the grove. Or tuck the Sunday *San Francisco Chronicle*'s "pink pages" entertainment section under your arm, pack a thermos of coffee, and throw down a blanket for a leisurely weekend read.

essentials

19th Avenue and Sloat Boulevard, San Francisco, CA 94116

(415) 252-6252

sterngrove.org

$ Free

Daily, sunrise–sunset

Muni bus: 23, 28; **Muni Metro:** K, L, S to transfer points; free bike valet service

peaceful place 99

SOUTH PARK

South Park (MAP TWO)

CATEGORY ⌇ parks & gardens ✪

*I*t's hip to be oval. In a neighborhood of streets laid out on a classic grid pattern, South Park strikes its visitors as, to use today's term, a little random. But the park's elliptical shape, along with its hidden location within a large city block, accounts for its charm. Constructed in the 1850s as the communal terrace for an exclusive residential enclave, the park is an unexpected and leafy retreat just steps away from heavily trafficked thoroughfares.

Over the decades, the neighborhood surrounding the park has morphed from genteel to downtrodden to commercial to arty. In its latest incarnation, South Park has been a kind of ground zero for dot-com start-ups and their successors, the wizards of social networking. Today, it's a casual place for low-key meet-ups, dog-walking, taking a breather, and even moving business out of a sterile office into a greener environment. Fringed by curvilinear sidewalks that give it a European feel, this city treasure also affords a great place for a cool stroll on a warm day. On the park's north side, a contingent of charming cafes welcomes people who can linger over a bistro lunch or a glass of wine, enjoyed at a cluster of sidewalk tables when the weather permits. One caution: it's best to absorb the park's charms during the day, as it's in a transitional neighborhood. Take care in deciding when to visit for peaceful walks and dining.

✌ essentials

|✉| South Park Street, bounded by Second, Third, Bryant, and Brannan streets, San Francisco, CA 94107

(☎) N/A

(🌐) N/A

$ Free

(🕐) Open 24/7

🚍 **Muni bus:** 10; **Muni Metro:** K, T

peaceful place 100

STANFORD MEMORIAL CHURCH AT STANFORD UNIVERSITY

Palo Alto (MAP NINE)

CATEGORY ✎ spiritual enclaves ✪ ✪ ✪

*T*he Stanford Memorial Church is, in a word, divine. One of the university's architectural icons, this striking house of worship dominates the inner quadrangle, mixing superb Romanesque architecture with California's Mission style. Completed in 1903, the chapel was one of the earliest and most prominent nondenominational churches in the American West. Fulfilling the vision of Jane Lathrop Stanford, a cofounder of the university with her husband, Senator Leland Stanford, the chapel remains at the school's spiritual core and serves as a sanctuary for all who enter.

A masterpiece of design, the church is constructed of buff-colored sandstone that university historians say was quarried not far from the campus site and carved by Italian stonecutters. If you are like most visitors, you'll be drawn first to the visually arresting mosaic murals, composed of colorful tesserae (small cut pieces of stone, marble, or glass) and depicting Old Testament and New Testament scenes. The building's north facade will astound, with its massive mural that features Christ welcoming the righteous into the Kingdom of God. Inside "MemChu," you'll find a sanctum of quiet yet exhilarating beauty. Under a domed ceiling, archangels rise among the clouds, prophets adorn the stained glass, gold-lettered inscriptions inspire, and organs resound with sacred music.

⌄ essentials

✉	450 Serra Mall, Building 500, Stanford University, Stanford, CA 94305
☎	(650) 723-1762
🌐	stanford.edu
$	Free
🕐	Monday–Friday, 8 a.m.–5 p.m.; see Web site for scheduled services and events
🚌	**Caltrain:** Palo Alto Station; **Stanford Marguerite Shuttle** (the university's free bus) operates routes from Caltrain to multiple campus locations

peaceful place 101

SUNSET CRUISE, ANGEL ISLAND–TIBURON FERRY

Tiburon (MAP EIGHT)

CATEGORY ⌄ scenic vistas ✪ ✪ ✪

*A*t sea about how to spend a blissful summer evening? Consider the Sunset Cruise, offered on Friday and Saturday nights from May through October, when the Angel Island–Tiburon Ferry commuter fleet sees its last weary workers home and takes on the role of a small-scale cruise line. The idea is to bring along a moveable feast and your favorite cocktail-hour libations, which you enjoy as the crew slowly navigates the ship past points of interest around the San Francisco Bay.

The 90-minute excursion takes you past picturesque bay-side communities and offers up mind-blowing views of San Francisco, Angel Island, and, arguably, the world's most beautiful bridge. The biggest payoff comes at dusk, when always-changing sunsets paint the sky crimson, big fists of fog push their way past Mount Tamalpais, and lights start to sparkle on the horizon.

Our excursion was refreshingly free of crowds, and everything about the tour was casual and unfussy. Though there's seating inside the ferry, the upper deck affords a more dramatic way to enjoy the spell-binding vistas. Here, where we could take in big draughts of salty air and listen to the calls of gulls, we got a sense of being true seafarers.

⌄ essentials

▣ 21 Main Street, Tiburon, CA 94920 📞 (415) 435-2131 🌐 angelislandferry.com

$ Adults and seniors, $20; children ages 6–12, $10; children ages 3–5, $5; children age 3 and under (one free child per accompanying adult), free

🕐 May–October, Friday–Saturday, 6:30–8 p.m.

🚌 **Ferry service:** Angel Island–Tiburon Ferry

peaceful place 102

SUNSET MAGAZINE GARDEN

Menlo Park (MAP NINE)

CATEGORY ⌣ parks & gardens ✪ ✪

*T*f you're a Bay Area resident, you live in one of the climate zones from 14 to 17. So say the people at *Sunset* magazine, the decades-long authoritative voice of lifestyle and gardening in the West. Local green thumbs enjoy the blessings and challenges of ocean influences, marine effects, and coastal thermal belts that can make or break plant performance.

To learn more about all 24 major climate zones, which encompass everything from the wet Northwest to the desert Southwest, visitors can take a self-guided walking tour of the *Sunset* garden. Located at the magazine's offices in Menlo Park, the garden encompasses a lush 1-acre lawn of colonial bent grass, along with hundreds of trees, blooming shrubs, perennials, ground covers, and ornamental shrubs. There's

A graceful tree shades the Sunset *Magazine Garden.*

even a testing area, with plants and projects slated for possible coverage in upcoming *Sunset* issues. Whether you're a serious horticulturist, landscape designer, or backyard novice, you'll delight in these lovely and tranquil grounds. Just try not to feel envious that this is where 60 lucky and peaceable souls are privileged to work every day and stroll in the garden from time to time.

essentials

80 Willow Road, Menlo Park, CA 94025

(650) 321-3600

sunset.com (click on "The Magazine," and scroll down to find "Tour Sunset's Gardens")

Free self-guided tour

Monday–Friday, 9 a.m.–4 p.m. (except holidays and the week before the magazine's Celebration Weekend, a public open house and festival in early June)

SamTrans bus: 397

peaceful place 103

THREE GEMS, DE YOUNG MUSEUM

Golden Gate Park (MAP SIX)

CATEGORY ⌣ urban surprises ✪

California artist James Turrell doesn't work in paint or bronze but in light. Commissioned by the de Young Museum to create an outdoor art installation for its Barbro Osher Sculpture Garden, Turrell produced a "skyspace" that links the museum's interior with the parkland's lush outdoor environment. Turrell's *Three Gems* skyspace takes the form of a stupa, or dome, and is nestled in the garden's grass-covered hill.

The structure resembles a small naked-eye observatory, with a circular opening carved into the ceiling and a concrete bench running around the inside perimeter. The aperture and the intimacy of the simple enclosure encourage you to look upward and contemplate the sky, framed by the open roof. You'll notice how the seasons, time of day, and weather conditions alter the lighting effects and atmospheric colors. Turrell encourages you to suspend your customary perceptions and view the sky not as celestial phenomena but as abstract art. His use of color may add to your emotional response. He has painted the dome's outer wall orange, a complement to blue on the color wheel, a pairing that makes the sky seem to vibrate. The inner bench accommodates about 20 people, but this meditative experience is best enjoyed in solitude or with one or two friends.

∽ essentials

☐ 50 Hagiwara Tea Garden Drive, San Francisco, CA 94118

☎ (415) 750-3600

🌐 famsf.org/deyoung

$ Adults, $10; seniors age 65 and up, $7; children ages 13–17 and college students with ID, $6; children age 12 and under, free, admission free on the first Tuesday of every month. See page 53 (de Young Museum Observation Deck) for more fee information.

🕐 Tuesday–Sunday, 9:30 a.m.–5:15 p.m. (extended hours Friday mid-January–November until 8:45 p.m.); closes at 3:30 p.m. on December 24 and 31; closed New Year's Day, Thanksgiving, and Christmas

🚌 **Muni bus:** 44; **Muni Metro:** N

peaceful place 104

TIN HOW TEMPLE

Chinatown (MAP ONE)

CATEGORY ⌒ spiritual enclaves ✪

century ago, Waverly Place harbored a warren of gambling, opium, and prostitution dens in the heart of Chinatown. Today, this two-block alley bears little trace of its notorious past, except for its theatrical buildings decorated in an Orientalized style. This "street of painted balconies" features colorful pagoda-style roofs, ornamental facades, and recessed top stories that conceal tiny temples.

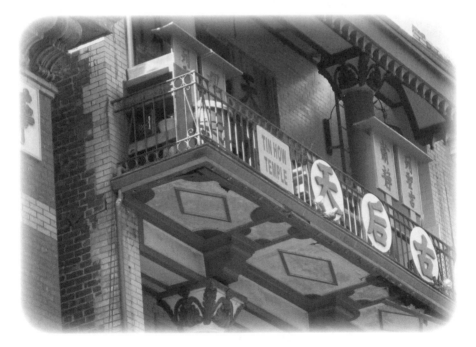

The temple is dedicated to the Queen of the Heavens and Goddess of the Seven Seas.

To get a sense of Chinatown's spiritual side, seek out the shrine on the uppermost floor at 125 Waverly. Here worshippers pay homage to Tin How, the Queen of the Heavens and Goddess of the Seven Seas. The heavy scent of incense guides you up several flights of nondescript stairs to a one-room sanctuary, whose namesake deity is the protector of seafarers and immigrants. Dozens of lanterns festoon the ceiling, mimicking the moon's luminescence. When I visited during Chinese New Year, each lantern was decorated in red, signifying an auspicious future. Plates of fresh oranges and other fruits sat neatly arranged on ancient altars, offering up a prayer and a wish for good fortune. Sticks of incense and small bundles of burning paper sent up trails of smoke, which formed a currency with which to repay debts to ancestors in the spirit world.

The temple's caretakers speak primarily Chinese, but there's no need for translation. The symbols of prayer and reverence seem universal.

essentials

125 Waverly Place, San Francisco, CA 94108

N/A

N/A

Free

Daily, 9 a.m.–4 p.m.

Muni bus: 1, 30, 45; **Cable car:** California Street, Powell/Hyde Street, and Powell/Mason Street; **Muni Metro:** Montgomery Street Station; **BART:** Montgomery Street Station

peaceful place 105

TRANSAMERICA REDWOOD PARK
Financial District (MAP ONE)
CATEGORY ⌇ parks & gardens ✪ ✪

*J*t may be the granddaddy of San Francisco's pocket parks, but this oasis at the edge of the Financial District still basks in relative obscurity. Shaded by the city's tallest skyscraper—the 853-foot-high Transamerica Pyramid—this unexpected gem sits just far enough away from the commercial area to escape detection by the masses.

Despite its neighbor's soaring height, the dappled space gets sufficient sun to warm up the handful of lunchers and loungers who do stop by. With a salad from one of the

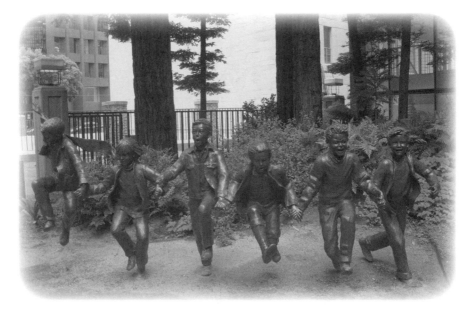

Glenna Goodacre's Puddle Jumpers *will inspire you to smile.*

nearby eateries in hand, I often head for the park, where I can depend on an hour of carefree solitude.

Fragrant redwoods line the park's perimeter, and a mass of ferns, mossy ground covers, and flowering shrubs creates a forest-floor effect. Frothy fountains splash in a man-made frog pond and mask the sound of traffic on nearby streets. Bronze sculptures of leaping amphibians and children at play add to the charm, and a plaque commemorates two legendary stray dogs. The canines—Bummer and Lazarus—reputedly had the run of the area in the mid-1800s, when they attached themselves to Emperor Norton, a celebrated and eccentric San Francisco resident and self-proclaimed emperor of the United States.

Note: If a long-discussed (and much-opposed) proposal to build a nearby residential tower gets under way in the future, construction will temporarily disrupt the quiet luxury of this treasured enclave. As part of that plan, Transamerica Redwood Park may be expanded—losing its charm as a hidden treasure but gaining stature as a green and potentially tranquil urban site that would no doubt please Emperor Norton.

essentials

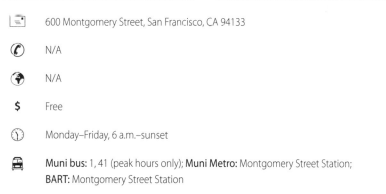

600 Montgomery Street, San Francisco, CA 94133

N/A

N/A

Free

Monday–Friday, 6 a.m.–sunset

Muni bus: 1, 41 (peak hours only); **Muni Metro:** Montgomery Street Station; **BART:** Montgomery Street Station

peaceful place 106

WAR MEMORIAL

Civic Center (MAP THREE)

CATEGORY ⌣ historic sites ✪ ✪

hough the San Francisco War Memorial & Performing Arts Center's name implies the presence of a military tribute somewhere on its grounds, the memorial to our nation's veterans has been more a figment of goodwill and imagination than a reality, thus far. Envisioned more than 70 years ago, the commemoration has long been stalled by administrative and financial obstacles. Now, the country's wartime involvements and increased military sacrifices have rekindled a campaign—led by community leaders, veterans, and individuals with a penchant for art and military history—to create and install the physical tribute.

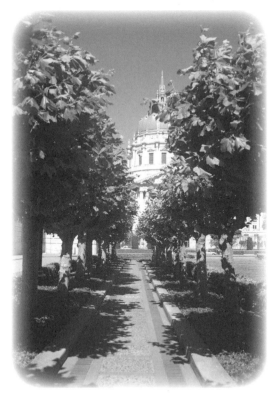

Decades ago, planners designated the sacred spot that will support the remembrance, an octagonal space that lies on the verdant rectangular lawn between the War Memorial

The allée of trees frames a view of City Hall.

Veterans Building and its companion Opera House. And, while most San Franciscans may not know it, soil from the battlefields of the two World Wars and the Vietnam War already lies there. The completed project—designed by a team of artists and architects selected from proposals submitted to the War Memorial Board of Trustees and the San Francisco Arts Commission—will ideally be a water feature, with nearby seating space. Watch for its dedication, targeted for November 11, 2013—Veteran's Day of that year.

Meanwhile, the two buildings of the Performing Arts Center, constructed in the 1930s in the Beaux Arts style, have long been a visually striking respite for passersby, arts patrons, and even drivers traversing the city on the nearby busy streets. A view of City Hall, with its resplendent dome, the fifth largest in the world, unfolds to the east across Van Ness Avenue. Whether you visit now or after the dedication, the commemoration site is a serene place to pause and reflect.

✌ essentials

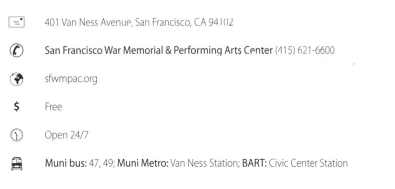

401 Van Ness Avenue, San Francisco, CA 94102

San Francisco War Memorial & Performing Arts Center (415) 621-6600

sfwmpac.org

$ Free

Open 24/7

Muni bus: 47, 49; **Muni Metro:** Van Ness Station; **BART:** Civic Center Station

peaceful place 107

WAVE ORGAN
Marina District (MAP FIVE)
CATEGORY ✿ urban surprises ✪✪✪

*P*art weird science, part art installation, and part musical instrument, the San Francisco Wave Organ is a must-see (and hear) wonder. Located on a tiny jetty by the Marina District yacht harbor, the wave-activated sculpture has been entertaining cult fans and curious first-timers since its installation in 1986.

Created with granite and marble from a demolished cemetery, the environmental work was conceived by an artist and a master stonemason under the auspices of the

When waves hit the jetty, the organ plays its musical composition.

Exploratorium, San Francisco's hands-on science museum nearby. Like some bedrock-styled set from *The Flintstones*, the place features a craggy amphitheater that overlooks the surrounding bay. Twenty-five pipes protrude from the stair-stepped stone, with their other ends submerged in the water. When wave activity causes water to flow into and then recede from the pipe ends, the organ produces sound. To experience this aqueous symphony, take a seat in the "listening booth" or lean toward one of the periscope-like openings.

Nothing on the level of a Bach fugue, the emanating music is more akin to esophageal gurgling or the sounds of draining plumbing. But you are here for the quirkiness, not the lyricism. Auditory quality is finest at high tide, so check the Internet for local tide predictions. If you brave the place at an early hour, you may be treated to a gorgeous sunrise, depending on the time of year. But no matter when you visit, you'll find it mesmerizing to be on this tiny sliver of land, with your ears attuned to foghorns, lapping waves, and the organ's underwater murmurs.

essentials

End of Yacht Road in the Golden Gate National Recreation Area, San Francisco, CA 94123

N/A

exploratorium.edu/visit/wave_organ

Free

Open 24/7

Muni bus: 30, 30X

peaceful place 108

WILLIAM STOUT ARCHITECTURAL BOOKS
Jackson Square (MAP ONE)
CATEGORY ⌣ shops & services ✪ ✪

*Y*ou could easily walk past this small bookstore without knowing that it carries some of the most sought-after volumes in the city. An important resource for practicing and aspiring designers, the shop deals in more than 20,000 titles that span the realms of architecture, art, urban planning, graphic and industrial design, interior design, decorative arts, and landscaping.

The bookstore got its start 30 years ago when architect and publisher William Stout traveled to Europe and began sourcing hard-to-find architectural books for the San Francisco design community.

Though precariously close to lively North Beach, the store is located on a hushed tree-lined block in Jackson Square. Here you'll find no trappings of the soulless mega-booksellers that

Art and architecture define themes here.

have overtaken San Francisco—just reading-room quiet, some light jazz, worthy titles, and rafter-high shelves of gorgeous books.

With its immense selection of American and international titles, the store feels both San Franciscan and global. The staff maintains a respectful distance, allowing you to browse undisturbed. You may even want to buy a Black Dot sketchbook and try your own hand at design.

essentials

📧 804 Montgomery Street, San Francisco, CA 94133

📞 (415) 391-6757

🌐 stoutbooks.com

$ Free; **Book prices:** $10–$1,500

🕐 Monday–Friday, 10 a.m.–6:30 p.m.; Saturday, 10 a m.–5:30 p.m.

🚌 **Muni bus:** 8X, 10, 12; **Muni Metro:** Montgomery Street Station;
 BART: Montgomery Street Station

peaceful place 109

YERBA BUENA GARDENS

South of Market (MAP TWO)

CATEGORY ↵ parks & gardens ✪

At first glance, the Yerba Buena Center for the Arts seems like just another concrete enterprise—a pulsing collection of movie theaters, art galleries, museums, and a refurbished 1906 carousel. Thanks to the Yerba Buena Gardens, though, this commercial environment gets some softening around the edges. Here you'll find 5.5 acres of pastoral landscape and a be-all and end-all urban waterfall.

The gardens host woodland groves, benches for lounging, a grassy meadow for sprawling in the sun, and necklaces of pine, sycamore, and flowering trees. The 50-foot waterfall, which cascades over a granite precipice, is sheer poetry in motion. Behind it lies the Martin Luther King Jr. Memorial, which features panels inscribed with King's poems, along with photographs from the civil rights movement. The terrace provides seating for contemplation amid colorful flower beds, a wisteria-covered loggia, and a bed of plants native to San Francisco's—who knew?—13 sister cities around the world.

A favorite of students, South of Market workers, and conventioneers from nearby Moscone Center, the gardens see a fair amount of visitors at lunchtime on sunny days. You may even encounter an outdoor concert. But you'll still find ample joys in taking a misty walk behind the waterfall during off-hours, tossing some coins into the fountain, or stretching out on the lawn with a few other carefree souls.

✌ essentials

⊡ Bounded by Mission, Third, Folsom, and Fourth streets, San Francisco, CA 94103

☏ (415) 820-3550

🌐 yerbabuenagardens.com

$ Free

🕐 Daily, 6 a.m.–10 p.m.

🚌 **Muni bus:** 5, 6, 14, 30, 45; **Muni Metro:** Montgomery Street Station;
BART: Montgomery Street Station

peaceful place 110

ZARAGOZA

San Anselmo (MAP EIGHT)

CATEGORY ↙ shops & services ⊕ ⊕ ⊕

*I*s it better to give or to receive? The answer to that question is a tough call at Zaragoza, a store that specializes in art, artifacts, and accessories for the well-dressed home. You will definitely want to have and to hold some of these objects, but a spirit of generosity may also move you to share them with friends.

Zaragoza is a contemporary cabinet of curiosities, taking as its cue the wonder rooms of old Europe, where rulers and aristocrats showcased items sourced from the worlds of art, archaeology, architecture, geology, and natural history. In this light-filled space, where the objects of desire have lots of breathing room, merchandising is an art form in itself. With a transcendent talent for marrying color, pattern, shape, and texture, the owner and design guru of this store creates eye-catching and captivating vignettes. Luminous seashells and botanical paintings mix with nature-inspired jewelry and one-of-a-kind serving bowls. You'll also find sculpted-wire bird's nests, planetary-themed mobiles, and natural-science oddities.

If shopping is your guilty (and peaceful) pleasure, there's no better retail sanctuary in which to indulge. You may enter with a just-looking mind-set, but you'll undoubtedly leave with a coveted purchase in tow.

⌁ essentials

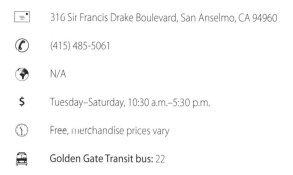

316 Sir Francis Drake Boulevard, San Anselmo, CA 94960

(415) 485-5061

N/A

Tuesday–Saturday, 10:30 a.m.–5:30 p.m.

Free, merchandise prices vary

Golden Gate Transit bus: 22

DEAR CUSTOMERS AND FRIENDS,

SUPPORTING YOUR INTEREST IN OUTDOOR ADVENTURE, travel, and an active lifestyle is central to our operations, from the authors we choose to the locations we detail to the way we design our books. Menasha Ridge Press was incorporated in 1982 by a group of veteran outdoorsmen and professional outfitters. For 25 years now, we've specialized in creating books that benefit the outdoors enthusiast.

Almost immediately, Menasha Ridge Press earned a reputation for revolutionizing outdoors- and travel-guidebook publishing. For such activities as canoeing, kayaking, hiking, backpacking, and mountain biking, we established new standards of quality that transformed the whole genre, resulting in outdoor-recreation guides of great sophistication and solid content. Menasha Ridge continues to be outdoor publishing's greatest innovator.

The folks at Menasha Ridge Press are as at home on a white-water river or mountain trail as they are editing a manuscript. The books we build for you are the best they can be, because we're responding to your needs. Plus, we use and depend on them ourselves.

We look forward to seeing you on the river or the trail. If you'd like to contact us directly, join in at www.trekalong.com or visit us at www.menasharidge.com. We thank you for your interest in our books and the natural world around us all.

SAFE TRAVELS,

BOB SEHLINGER
PUBLISHER

photographed by Doug Akagi

℟aynell Boeck is a city dweller at heart. She has spent most of her adult years in San Francisco, the thriving and gorgeous West Coast metropolis that incites visitors to dream, poets to rhapsodize, and residents to stay put. A Bay Area business editor, writer, and public-relations executive, Boeck has been connected with the city's arts and literary community for more than 30 years. She is a recipient of the International Association of Business Communicators' Gold Quill Award and numerous other honors from the Public Relations Society of America, the League of American Communications Professionals, and the Communicator Awards for corporate journalism.